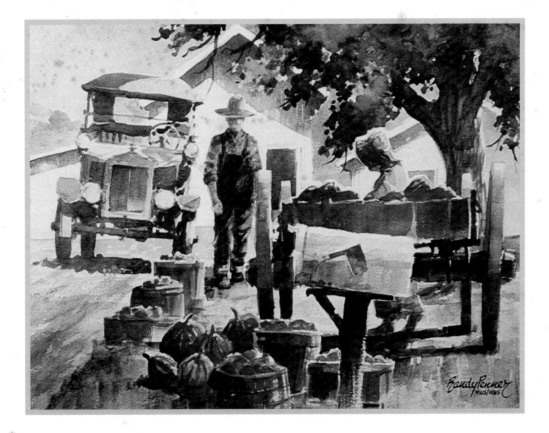

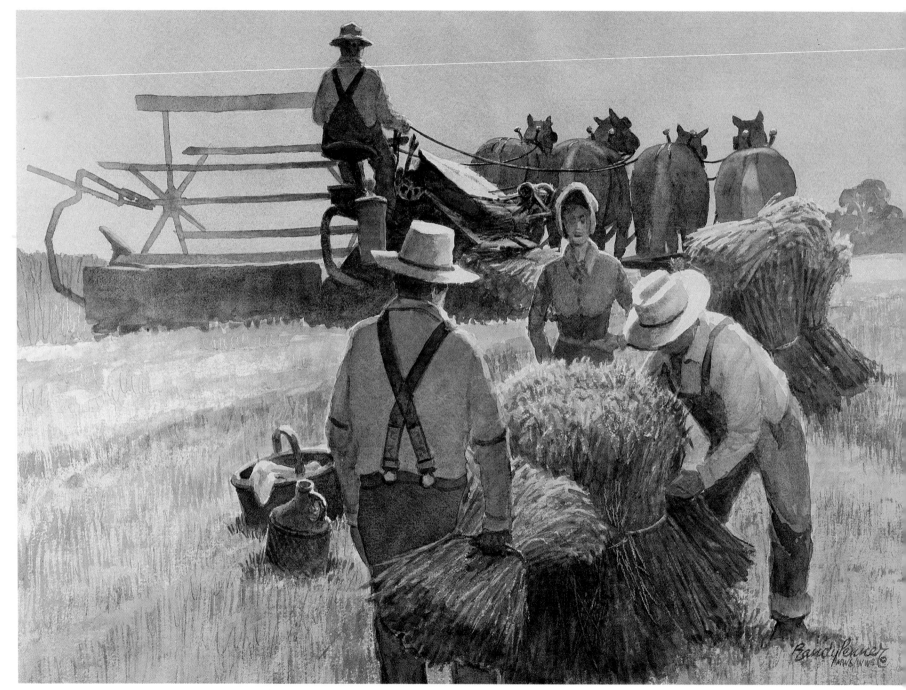

Lunch in the Field

A HARVEST OF MEMORIES

*Illustrations and Recollections
by Randy Penner*

Country Books

Cover Illustration: *The Threshing Crew*

A HARVEST OF MEMORIES

Illustrations and Recollections by Randy Penner

Publisher: Roy J. Reiman
Editor: Rick Van Etten
Associate Editors: Nick Pabst, Kristine Krueger
Art Director: Maribeth Greinke
Production Assistants: Ellen Lloyd, Judy Pope

©1996 Randy Penner
Reiman Publications, L.P.
5400 S. 60th St., Greendale WI 53129

Country Books

For additional copies of this book or information on other books, write:
Country Books, P.O. Box 990, Greendale WI 53129.
Code number of this book is 20390.
Credit card orders call toll-free 1-800/558-1013.

CONTENTS

ART AVAILABLE
Most of the illustrations from this book are available for purchase.
Contact Randy Penner, Pennerama Studio,
1140 Riverside Drive North, Hudson WI 54016; 715/386-2560.

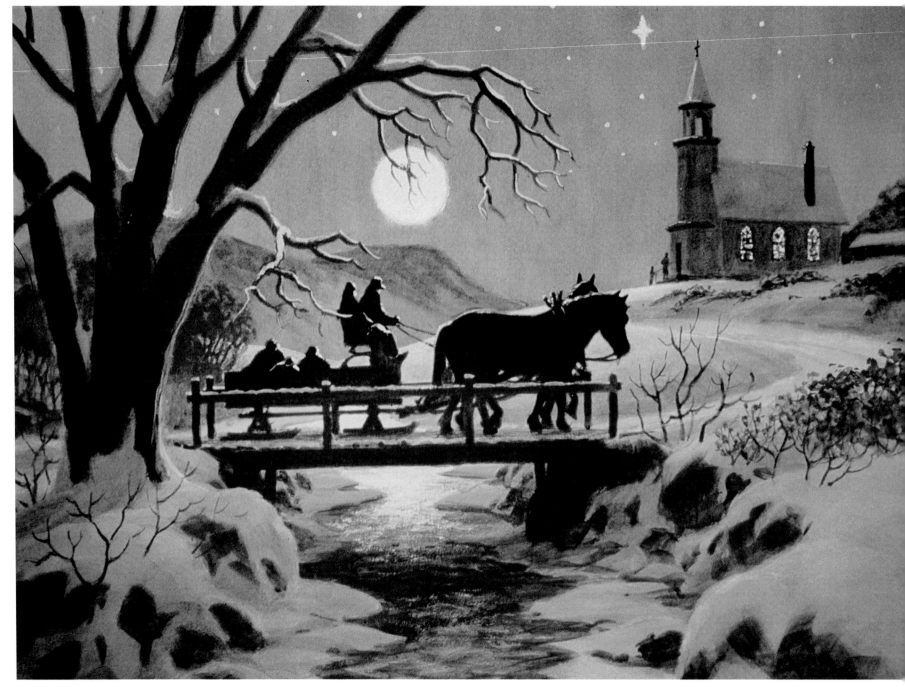

Heading to Midnight Mass

INTRODUCTION

His Paintings Bring Memories Alive

By Roy Reiman

I FIRST became acquainted with Randy Penner's artwork back in 1991, when he sent us some samples to be considered for use in *Reminisce* magazine. I liked his work right away—many of his illustrations showed farm scenes, and some of them took me back to the Iowa farm where I grew up.

In the roundabout way that things often happen in the publishing business, we ended up using one of his paintings on the cover of one of our company's other magazines, the December/January 1992 issue of *Farm & Ranch Living*.

We felt that the painting, entitled "Heading to Midnight Mass", perfectly combined a sense of nostalgia with the holiday spirit—exactly the feeling we wanted to convey.

Indicative of how much we thought our *F&RL* subscribers would enjoy this piece is the fact that this marked only the second time we used a piece of art (rather than a photo) on the cover of that magazine.

It proved to be a very popular choice. Subscribers immediately began contacting us, asking if they could buy a larger copy of the painting. Randy happily obliged by offering it as a limited-edition print.

When we first began working out the details of using the painting on our cover, Randy and I exchanged correspondence. I learned that he grew up on a Kansas farm during the Dust Bowl era and the Great Depression, and that most of his paintings are based on his vivid memories of rural life back then.

"Even though times were tough, I still regard those as 'the good old days'," he wrote. (I still have some of those early letters of his on file.) "Let the younger artists paint the dilapidated barns and abandoned machinery—I prefer to depict those times and those people when they were alive, well and happy!"

That positive spirit is evident in Randy's work, and it pretty well sums up his outlook on life as well. Now in his 70's, Randy lives in Hudson, Wisconsin with his wife, Luella. He's still mighty active and—fortunately for us—still painting.

If I had to put my finger on what I like most about Randy's work, I'd say it's the hard-to-define quality that lets me immediately *recognize* the scene he's depicting. For example, one of his paintings—it's included in this book—shows him as a youngster catching a snapping turtle in the creek.

The colors in this painting are subtle; there's nothing about the

picture that "shouts" at you. But nevertheless, I immediately relate to what's going on in that scene! See, I can still remember wading barefoot in the creek on our place back there in Iowa, trying to catch minnows, crawdads and turtles. In Randy's painting, that could be me in those overalls and straw hat.

The rest of his work affects me the same way. Whether it's something as dramatic as a farm wife hurrying to gather her laundry off the clothesline before an impending storm, or something as simple as a meadowlark singing atop a fence post, Randy's paintings ring true. They're not fancy; they're authentic. They make you feel you're *there*.

In this book, Randy has supplemented his art with firsthand recollections. Like Randy's illustrations, some of his anecdotes are informative, some are amusing or whimsical and some are poignant. And again, like his art, they're all authentic.

During a recent conversation, Randy referred to this book as his legacy. It's a fitting description. In *A Harvest of Memories*, Randy Penner has captured and preserved a way of life that will long be treasured by anyone who has roots in rural America.

—*Roy Reiman*
Greendale, Wisconsin
1996

ACKNOWLEDGMENTS

THERE ARE a few people to whom I must give special credit for their help in preparing the text and illustrations in this book.

The first is Oliver R. Unruh. Oliver still lives on his family's home place in the area where I grew up. Oliver attended the same school I did and went to the same church to which my family belonged. Being near my age, he was a great help in verifying some of my recollections and remembering a few things that I had forgotten.

Next is Loretta Penner Krehbiel. Loretta, one of my twin half-sisters, was also a great help in filling in a number of details about which I was a bit unclear. I was amazed at the clarity of her memories of our old home place.

Robert Orf is an old farm boy who lives near my current home in Hudson, Wisconsin. Bob is a good friend who shared many memories of living on the land. Even though separated by geography, many of the farming practices were the same in Wisconsin and central Kansas. Bob still owns some old farm tools that are now museum pieces. His help was invaluable regarding details that I wanted to verify for the sake of accuracy, details that have somehow escaped me over the years.

I dedicate this book to

...the memory of my mother, whose love I knew for all too short a time.

...the memory of my father, who persevered through adversity.

...my sister, Hilda, and the memories of our happy times growing up together.

...and my wife, Lu, who also has rural memories and has been tremendously supportive of my every effort through the years. She typed the manuscript for this book, all the while serving as a discerning—but loving—critic of my work.

Adele Lichti West—"Miss Lichti"—was a very special person. She patiently introduced me to the world of education when my formal schooling began in that one-room country school. Her vivid recollections, quoted verbatim in the "School Days" section, certainly enhanced this book.

Others who provided useful information, memories and photographs for reference and use in the family section include John R. Nickel, Dora Riesen Fry, Norma Bartel Ruff, Betty Bartel Jost, Pete Knaack, Ray Funk, Peter R. Kaufman, Arlen Miller, Bob Dabruzzi, Michael Murphy, Orville Waltner, Harvey Jongeling, Marvin Mangers, John and Joy Reis, M.D. Wasemiller, Richard Jantzen, Clarence Niles, Raymond Wiebe, Lyle Yost, Virgil Litki, Elmer K. Schroeder, Roland Ewert, David Nickel and Orville Penner.

Pertinent information on farm implements was provided by Pioneer Village at Minden, Nebraska; the Mennonite Heritage Complex at Goessel, Kansas; and Heritage Village at Mt. Lake, Minnesota.

Finally, special thanks to Dr. Luther L. Fry and Pat Lightcap for allowing paintings from their private collections to be included here.

How This Book Came to Be

The artist at work in his studio in Hudson, Wisconsin.

WRITING AND ILLUSTRATING a book about my youth on a mid-state Kansas farm has been a dream of mine for quite a few years. My childhood occurred during the 1920's and '30's, the years of the Great Depression, drought, dust storms, grasshopper plagues, and just about anything else that could and did test farmers to the limits of their endurance. Those times were, in many ways, among the most trying this country has ever experienced, and I felt that would lend drama to my story. After all, I was there when it all happened.

There are, of course, quite a few photographs of those difficult times, and many of them have found their way into some excellent books on the period. However, I felt that by illustrating many of my experiences from those years, I could add a personal dimension not present in many photos.

In the decades I have devoted to my work, both commercial illustrations and fine art, I have had to learn to be proficient enough to make a living through my efforts, modest though that living may be. There is great satisfaction in creating something with one's hands, and that is what art is all about, whether three-dimensional or two-dimensional.

The mind drives the creative process, and mental images are given form and substance. It is frequently said that one can only paint what one knows. One can know through reading, but that is not the same as actual experience. I have drawn

chiefly on my own experiences, rounded out by the recollections of others, in creating the illustrations for this book.

To those who may be wondering where I found photographs to copy in doing these illustrations, I didn't. In fact, few if any photos exist of many of the situations I have depicted. I relied mainly on memory and imagination, using photos of machinery for reference only on those occasions when I wasn't clear on the details.

In the workshops I have taught, I have always stressed that merely copying photos is a dangerous practice for anyone who wants to grow as an artist. As in any profession, only training and many years of intense practice will enable you to achieve mastery of your craft.

In my estimation, the great Harvey Dunn created the most powerful paintings depicting rural life that have ever been rendered. Dunn grew up in a sod hut in South Dakota and went on to become a successful illustrator in New York.

After contracting cancer and learning that his remaining days were few, he concentrated on painting the memories of his youth in rural

South Dakota, donating most of the finished works to his home state. Those works are now on display in the Harvey Dunn Museum of Art at the State University of South Dakota in Brookings, and are well worth making a trip to see.

Dunn "was there when it happened", and that makes all the difference. The utter conviction with which he portrayed those early pioneer days could only have come from personal experience. The authenticity that he brought to his work has provided me with life-long inspiration, and I have endeavored to bring the same degree of authenticity to my paintings and illustrations.

Speaking of authenticity and inspiration, I would also like to mention Regionalism, an art movement that developed during the 1930's. This movement was based in the Midwest and primarily focused on depicting rural life.

Artists who gained prominence as Regionalists were John Steurat Curry of Kansas, Thomas Hart Benton of Missouri, Adolph Dehn of Minnesota and Grant Wood of Iowa. Benton and Wood became the best known, and Wood's "American Gothic" and "Daughters of the Revolution" are true classics from the period.

The work of these Regionalists has provided me with additional inspiration throughout my career, and now I have the opportunity to share with you some of my feelings, as well as factual information, about what it was really like growing up when and where I did. I have tried to be candid, and accordingly there may be some surprises. I sincerely hope you will find my recollections interesting and enjoyable.

Randy Penner

To Set the Stage...

MORE AND MORE of late—now that I've joined the ranks of the old-timers—I find myself reflecting on my youth. My memories are composed of strong visual images of many events that transpired back then. I am grateful for the talent with which I was endowed that has enabled me to bring forth these memories in visual form and through the written word.

So that you can more fully appreciate the forces that shaped my life and my art, I'd like to share a bit of personal history, setting the stage, so to speak, for what is to follow.

Let me say at the outset that I still believe a farm is the best place in the world to grow up. Respect for nature and her creatures is learned there, and responsibility is acquired at an early age.

The central-Kansas farm on which I was raised, 3 miles northeast of the small town of Hillsboro in Marion County, was typical of the era and of our region, and probably typical of most other regions as well. (As many of you proceed through the following pages, you'll be able to see how your memories compare to mine.) Diversified farming was the norm, and we farmed 240 acres.

The area in and around Hillsboro was made up mostly of Mennonites. There were several branches of Mennonites represented in the region, with the Mennonite Brethren and General Conference Mennonites being the most prevalent.

I was baptized in the General Conference branch of the Men-

nonites, specifically the Brudertal Church, located about 3 miles from our farm.

My Roots

My father, Albert H. Penner, was one of 12 children born to Heinrich and Katharina Dalke Penner, both of whom came to the United States from Russia. Dad was born December 29, 1894. He attended Manhattan State Agricultural College, now Kansas State University, and farmed for many years until he and my stepmother moved into the town of Hillsboro. Dad was working in a lumberyard at the time of his death in 1967.

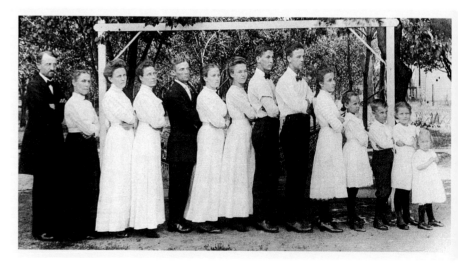

The artist's father, Albert H. Penner (sixth from right in the above photo), was one of 12 children born to Heinrich and Katharina Dalke Penner, both of whom came to the United States from Russia. Heinrich and Katharina are at far left.

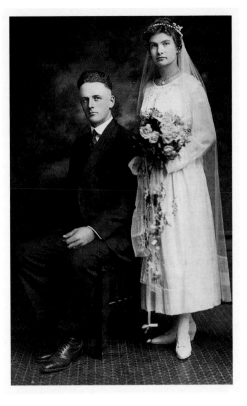

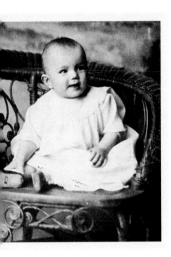

Although we now see death on television and in the movies, medical science has kept many younger folks from having to experience it or learn to cope with it at an early age. Certainly that was not the case in my own family, or any of the other families of that era.

My mother's parents, Henry and Katharina Funk Riesen, became especially close to me because of their proximity and their loving care during my mother's illness and after her death. Most references in this book to my grandparents are to them.

In August 1928, Dad married Susanna Krehbiel Loganbill in Geary, Oklahoma. Susie was also widowed and had three girls of her own, Vera, Eleanor and LaVeta. (Divorce, at that time, was almost unheard-of, and single-parent families were almost always the result of the untimely death of the husband or wife.) In 1930, twin girls, Lorene and Loretta, were born to Dad and Susie.

In 1919, Dad married Elizabeth Riesen. I was born in 1921, and my sister, Hilda, was born the following year. Mother died in September 1927 after a lengthy illness, which later was determined to have been leukemia.

Mother was one of five children. Her sister Hilda, for whom my sister was named, died during the influenza epidemic in 1919 while attending Bethel Academy in North Newton, Kansas.

Back then, families learned to accept death as part of the scheme of things. Farm animals died, pets perished and people passed on, but life as a whole continued. Nowadays, I can't help thinking that the reason so many people have such a difficult time coping with death is because they have not had to grow up with it.

Elizabeth Riesen, the artist's mother (standing at back left below), was one of five children born to Henry (center) and Katharina Funk Riesen (far right).

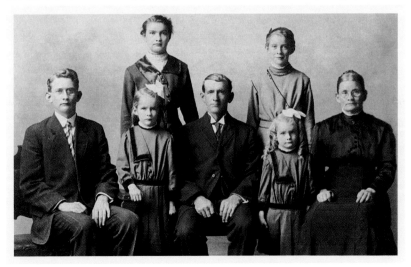

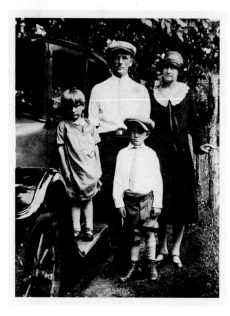

At left, Albert and Elizabeth Penner and children Hilda and Randy pose with their Star automobile. Above, the artist's grandparents, Heinrich and Katharina Dalke Penner, in 1925.

Dad met Susie through the Mennonite Church in Geary, where his father was serving as pastor. Grandfather Penner was also a teacher of the first order. The first school where Grandfather Penner taught was the Rosenort School, which later became the Lighthouse School I attended and refer to in this book.

Much earlier, Grandfather Penner established an academy in Hillsboro. The Penner Academy, as it was known, ceased to exist after Grandfather moved from Hillsboro to nearby Lehigh, where he was principal of the elementary school for 4 years.

My grandparents then moved onto the campus of Bethel College in North Newton, where Grandfather Penner taught for 4 more years before moving back to Hillsboro to begin his ministerial career.

As is the case with many ministers, Grandfather served churches in several states as well as serving the church conference in various capacities, including president. What I remember most about Grand-father Penner was that his thinking was far ahead of his time.

He dared to express his progressive thinking and at times was taken to task for this. There is no question that he was a man of vision.

After Grandfather's death in 1933, Grandmother Penner moved back to Hillsboro and lived in an apartment at the rear of the Henry Franzen home. When I was in high school, I would occasionally stop by and have lunch with her.

Mother's Untimely Death

Although I was only 6-1/2 years old when my mother died, my memories of her are all positive. She was truly a loving, caring woman. Of course, her suffering and death were definitely negative factors during my formative years.

I shall never forget Mother's final moments. My sister and I were called into the bedroom to be with her. Her illness had taken a terrible toll, and I still remember when she expired, finally relieved from

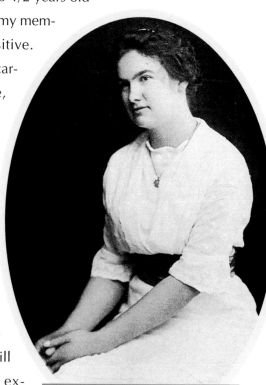

A studio portrait of Elizabeth Riesen Penner, the artist's mother.

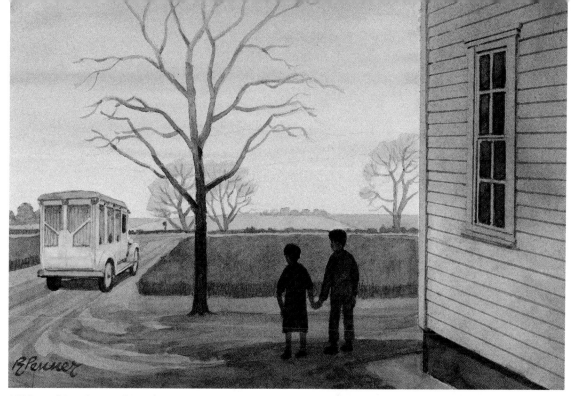

Hilda and Randy Watching the Hearse Depart

her suffering. I also well remember when H.N. Goertz, the undertaker, came in his white hearse to pick up Mother's body.

I must pay tribute here to my aunt, Sister Anna Gertrude Penner. As one of the Bethel Deaconesses, she lived in the Bethel Deaconess Home and Hospital in Newton, Kansas, some 20 miles south of Hillsboro.

When Mother became ill, Aunt Gertrude, a nurse, was granted a leave to stay with us and care for Mother. Aunt Gertrude also assumed all

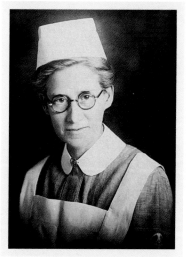

Sister Anna Gertrude Penner, Randy's aunt, cared for the family during his mother's illness.

the duties of the "lady of the house", which meant a lot of work. According to my Aunt Dora, my Grandma and Grandpa Riesen hired a housekeeper for us, but I don't remember that. I do recall that Aunt Gertrude stayed with us until Dad remarried.

The full impact of Mother's passing did not hit me until later, but the adjustment to her absence had to be made. If she had lived, my life would have been different, but life is full of ifs and could-have-beens.

A Small Town in Kansas

Agriculture was, of course, the dominant occupation in our region. If it hadn't been for the farmers, it's doubtful the town would have survived. After my mother's death, I spent a lot of time in Hillsboro with my Grandparents Riesen, who had retired to live in town. Their home farm was taken over by their son, my Uncle Adolf.

I still vividly remember downtown Hillsboro. One of the most prominent establishments on Main Street was Schaeffler's Mercantile Store, stocked with groceries and clothing. Yard goods were abundant and always a big seller because most women did their own sewing.

Schaeffler's also had a produce department where farmers took their cream and eggs. The cream was tested

for butterfat content and the eggs were candled for freshness. The farmers were given cash for the cream and eggs or credit toward purchases within the store.

Something I recall very well about that store's grocery department were the cracker barrels and the cookie boxes. The customer would remove the number of crackers desired with a metal scoop, and the cookies were removed with fingers. Can you imagine those

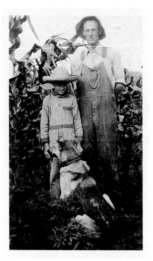

procedures being allowed today, especially the latter? At least the cookie boxes had lids made of glass so that the contents were visible. I'm not so sure that the crackers were covered at all times.

The Penner Drugstore (no relation) with its soda fountain was a favorite social spot of the town's young people.

Another of the establishments I remember especially well was the Gamble Store where I bought my rifle. P.G. Jost's blacksmith shop was where Dad took his plowshares to be sharpened. That was always a fascinating place to visit.

Not being a car nut, I never fre-

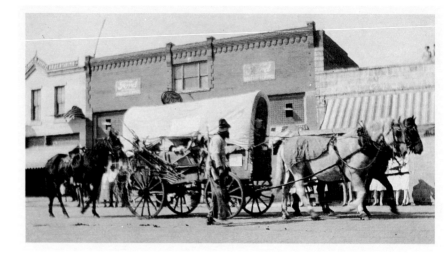

At left, Randy with his father and dog "Bess". Above, the school's entry in the Old Settlers parade celebrating the 50th anniversary of Hillsboro's founding.

quented any of the auto dealerships. The Kopper men's clothing store was operated by Bill Kopper, who dearly loved cigars—the store and all of the clothing therein carried a very distinctive tobacco aroma.

There was a cafe where beer was available, and it was known that some good church men would drive into the alley, park behind the cafe and sneak in to purchase their bottles of beer. In a small town like Hillsboro, not too much went unnoticed!

Old Settlers and the Marion County Fair

In 1929, Hillsboro celebrated the 50th anniversary of its founding. The celebration centered around an "Old Settlers" theme, and the festivities were held in conjunction with the county fair in October of that year.

I remember the parade and especially my grade school's entry.

Our entry was in the best tradition of the pioneer days, covered wagon and all. We kids and the teacher rode inside the wagon. Mr. Leonhard Bartel walked alongside, attired in pioneer garb and carrying a musket.

A saddled pony was tied by the reins to the rear of the wagon, and a team of horses pulled the wagon. Betty Bartel Jost remembers a bucket of cow chips hanging from the side of the wagon. Cow chips, like the more prevalent buffalo chips of those days of yore, were used to build fires.

The Marion County Fair was held in Hillsboro every year and was always a big event, focusing mainly on the many facets of local agriculture. A building housed food displays of all sorts, including garden products. For several years, I worked in the cattle tent where, because of my well-known interest in aviation, people jokingly told me I was now a pilot—my job was to "pile it here and pile it there"!

One of the things I remember best about the fair was the clown with the trained burro to which he was constantly saying, "Take your time but hurry up." (Despite these admonitions, the burro's speed never varied.) Another attraction was the old Model T with an eccentric axle driven by a clown. To me, it was hilarious seeing the vehicle go bobbing along.

Then there was the usual carnival with its rides and sideshow tent. We farm boys enjoyed listening to the barkers and viewing the tempting "samples" used on stage to lure the people in. I was skeptical of the barker's claims, however, as to what was inside the tent. Besides, I had very little money to spend, and I wasn't going to waste any of it to see some fakery!

I might add, each of these memories could have made a fine painting, but there are only so many pages in a book, and only so much time in a day to paint.

Other Entertainment

Visiting with other families and relatives was always a welcome interlude in the busy life of farm folk. These visits were usually relegated to Sundays, which was a time of rest from the week's labors.

It was a rare thing to see a farmer in the field on a Sunday. Chores, of course, had to be done on Sundays, because feeding the farm animals, doing the milking and gathering the eggs had to be taken care of daily.

When the Chautauqua came to town, many farm families took in the performances held under a huge tent. It was good wholesome entertainment, and educational at the same time.

I also remember the May Day celebrations in the park adjacent

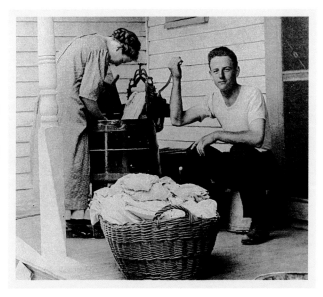

An early photo of the artist's father, Albert, helping his sister Christine with the laundry. At the time, Albert worked for Christine and her husband, J.J.R. Claassen, at the couple's Nebraska hog farm.

to Tabor College, a Hillsboro institution established by the Mennonite Brethren and located a block from where my Grandparents Riesen lived. I can still see the Maypole with girls, each carrying a long length of colored crepe paper attached at one end to the pole, walking round and round the pole until it resembled a tall multi-colored barber pole.

Randy with (right to left) stepsisters Vera and Eleanor, sister Hilda and stepsister LaVeta. This photo was taken in 1928 shortly after Albert Penner married Susanna Krehbiel Loganbill, a widow from Geary, Oklahoma.

Saturday evenings after the chores were done, I would often head into town on my horse, stable it in Grandma's barn and walk to downtown. My destination was the drugstore and the soda fountain. I would order a pint of strawberry ice cream and a bottle of root beer, which I considered a treat fit for a king!

The movie theater in Hillsboro was also a popular place to go for entertainment, especially for younger folks like myself. In fact, if that week's feature was something in which I was especially interested, I would see the movie several times.

The owner-operator of the theater knew all the kids. I would pay admission only on the first night. On successive nights for the same movie, I got in free. *Dawn Patrol* was one of the movies I saw every night it was shown. Other favorites were *Only Angels Have Wings* and *Test Pilot* with Clark Gable.

Some evenings, instead of riding my horse to Grandmother's, I'd go to the house of one of my bachelor friends. Often, a group of fellows would be there to play cards. Several of them were also bachelors. In fact, we had a number of bachelors in the community, as well as a number of "old maids".

These bachelors took the young fellows of our community under their wing, so to speak, and they were excellent teachers. I learned many things from them, like how to throw an open shoe consistently in horseshoes, how to put a curve on a baseball and how to swim and dive. And I re-

20

member very well the words spoken by one of the sage bachelors at times when we younger boys would get somewhat carried away with ourselves. He'd say, "Children should be seen, not heard."

My first radio was a crystal set given to me by a good friend, Waldo Nickel. On it I could get XERA out of Del Rio, Texas at night. Most of the programming consisted of western music, with Gene Autry the star attraction. I also remember listening to "Doctor" Brinkley from his renegade station just across the border in Mexico.

The Pranks We Pulled

Boys will be boys, of course, so there was bound to be mischief. However, we did not damage property, and vandalism was all but unknown.

One prank I remember well happened late one summer evening in front of a Hillsboro cafe. A number of us were sitting and standing around, just talking boy talk. A little Austin automobile, which would be called a sub-compact today, came along. The driver parked nearby and went into the cafe.

Somebody came up with the idea of lifting the Austin over the curb and depositing it in the alley, out of sight between the buildings. This was no big task for us brawny farm lads, and we were soon back in our places as if nothing had happened, waiting for

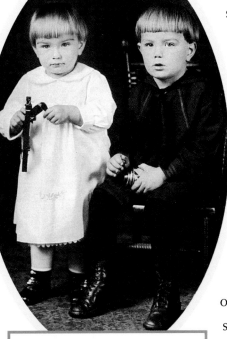

Portrait of Hilda and Randy Penner.

the Austin's driver to return. You can imagine his dismay upon discovering that his car was gone. We finally 'fessed up and returned his car to its rightful place. No harm done!

Another prank I was involved in I feel I must relate because it involved Paul Friesen, who later became one of the Toppers, the male quartet on the Arthur Godfrey show. Paul's dad was a Hillsboro banker, and they lived near Grandmother Riesen.

Paul became a playmate, and we did a lot of things together, some of which definitely qualified as mischief. One thing we did I can well recall. My aunts Dora and Elma were still living at home with my grandparents, so Paul and I sneaked into their bedroom, removed some lingerie from a dresser drawer and put it in a bag. We then tried to peddle it from door to door, with no success, of course.

I can still see the expressions on the faces of the housewives when they came to the door and saw our wares. Honestly, I can't remember whether it was my idea or Paul's, but I'll take the blame.

One last incident involved the county school superintendent when he made the rounds of the grade schools in Marion County. On the day Superintendent Rea visited our school, he discovered, when he was ready to leave, that he had a flat tire.

Our teacher sent several of us older boys out to help with the business of changing the tire, and "help" we did. The county superintendent sat down on the ground to change the tire. When he sat down, the overcoat he was wearing flared out, causing the pockets to partially open. Those of us boys not helping with the tire proceeded to deposit "horse biscuits" in said pockets. A couple of others kept him engaged in conversation, so the gentleman was completely unaware of what we were doing.

I cannot recall if there were any repercussions.

Law and Order in Rural Kansas

Back then, pulp magazines like *True Detective* dealt with crime in a lurid, sensational manner, helping to publicize the exploits of J. Edgar Hoover and his G-men as they pursued infamous Public Enemies. Sometimes those stories hit pretty close to home!

I recall the time that the notorious John Dillinger was thought to be in the area. Our grade school teacher, Mr. Goossen, had to cross a state highway in his Model T on his way to school. One particular morning while stopped to let highway traffic pass by, Mr. Goossen reported seeing none other than Dillinger himself driving by in his Ford. We kids were tremendously excited when we heard this later!

In our area, crime was so rare that when it did occur, it created a fair amount of excitement. It was usually nothing more than robbery or attempted robbery, and not on a large scale. I honestly cannot recall any murders in our area. If there was domestic violence, it went unreported.

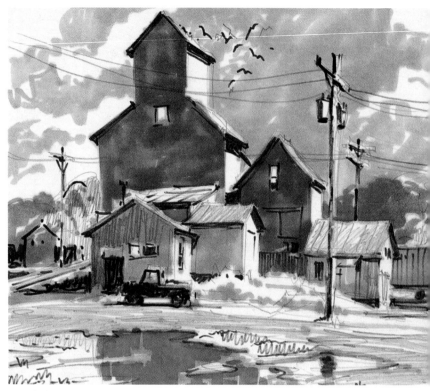
Rural Elevator

The one crime I recall most vividly was when a member of our church was caught stealing chickens from a farmyard. He was brought before the church body one Sunday morning to make his confession before God and man, and to ask for forgiveness. I cannot remember whether or not he received a sentence in our local court.

I remember well when the county sheriff, Lou Richter, appeared before our high school civics class to tell us about his duties. He brought along his Thompson submachine gun, and we were all

duly impressed! Richter was a big, muscular man, the type who would make a lasting impression on friend or foe.

Our town marshal was also a big man, but not as muscular, nor as brave. In fact, it was common knowledge that he was afraid of his own shadow. As is typical of men like that, he tried to make up for it with bluster and bravado.

The acid test came during the wee hours one summer night when some men robbed Schaeffler's Store. The nearby cafe owner called the marshal, and the marshal did appear on the scene. Instead of taking measures to apprehend the robbers, who were still in the store, he fired his Colt .45 automatic at the building.

Of course, the robbers fled, making their getaway with no interference from the good marshal, who was not about to get involved in a gun battle. The next morning, the marks left by the marshal's bullets were found near the top of the *second story* of the brick building, proving rather conclusively that he hadn't been trying very hard to catch the crooks.

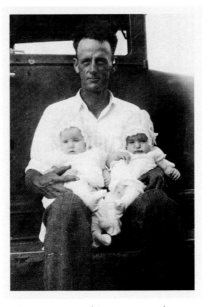
Twins Loretta and Lorene were born to Randy's father, Albert, and stepmother, Susie, in 1930.

Romantic at Heart

As I've already mentioned, my mother died when I was still quite young, and no one ever took her place in my heart, although a few of my aunts did become very good friends.

Perhaps because I was the only boy in our family, with a sister, step-sisters and half-sisters, I've always been pretty much a loner. For whatever reasons, I didn't have any girlfriends until I was in college.

I'm told I was a romantic, a dreamer, if you please. As a youngster, I found my romance in nature, and spent many hours enjoying her solitude.

Her creatures, moods and vistas were a source of wonder to me then, and they continue to be so to this day. Such is the stuff of which an artist's inspiration is made!

Some Final Thoughts

This book is about reminiscing. In looking back as I have, the good times tend to overshadow the bad times. I've come to under-

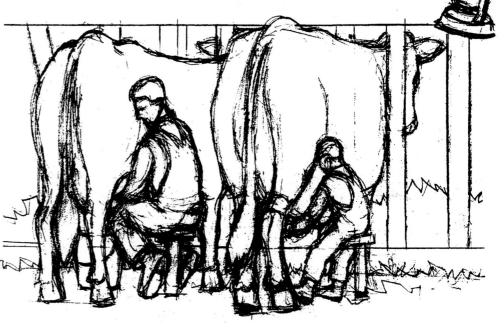

stand that it's true what they say: Time heals.

The changes that have occurred in my lifetime are mind-boggling, to say the least, and I'm sure that I am not alone in wondering whether all those changes have been for the better. Back then, it was truly a case of "have not, want not".

We didn't seem to hunger for needless material things back then. Was it because we were more insulated on the farm? We didn't get a daily paper, and the telephone was really our only means of communication. All lines were party lines, and that's how the news (and gossip!) was spread. Long-distance calls were almost always reserved for emergencies and reporting deaths.

Most families were rather patriarchal, to be sure, but usually there was still a pretty fair balance between the input of husband and wife into family affairs. Families worked together and that kept them together. The work ethic was an honest day's work (*long* days!) for what today would be considered a pittance.

Getting exercise certainly was not a problem on the farm. There was all kind of exercise, from light to heavy. I firmly believe that muscle tone needs to be developed at an early age along with the growth of the body. With a fair amount of physical activity along the way as one grows older, one is better off than those who have never known hard physical labor and who decide in later life to engage in some activity that is physically demanding.

Life today is so much easier than the life we knew during the '20's and '30's. Heated and air-conditioned tractor cabs were unknown, although I do remember large umbrellas on a few tractors. Many times, a broad-brimmed straw hat was the only protection from the hot sun.

Extra clothing was required for protection from the cold winds of winter, and the cast-iron seats on tractors and implements were mighty chilly when you first sat down on them—long johns under the overalls were an absolute must!

The language was far simpler and straightforward. It wasn't peppered with buzzwords. Love was love, not a "meaningful relationship", subject to cancellation on a whim.

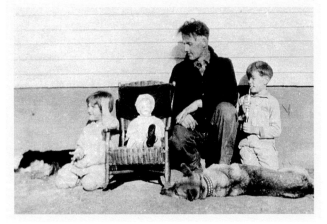

Hilda, Dad and Randy with farm dogs "Shep" and "Bess" in the summer of 1928.

We didn't worry about being politically correct. And suing was not in fashion. We didn't have law offices on every street corner either.

Yes, those were simpler times. Life was far less hectic, and there was no such thing as rush-hour traffic. Seeing cars on the road was not all that common, in fact, and one could usually identify the owner by the automobile.

Isn't it strange how humans often do not appreciate the significance of certain events until time tells us how much they really meant? This is certainly true of my life. When I was growing up on the farm, what with all the vicissitudes we experienced, I must say that I did not realize until much, *much* later how very fortunate I was to be spending my formative years in the country.

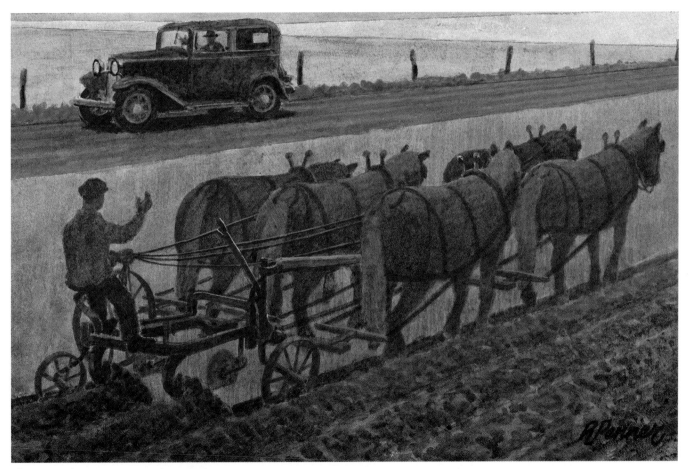

Plowing with Five-Horse Tandem Hitch

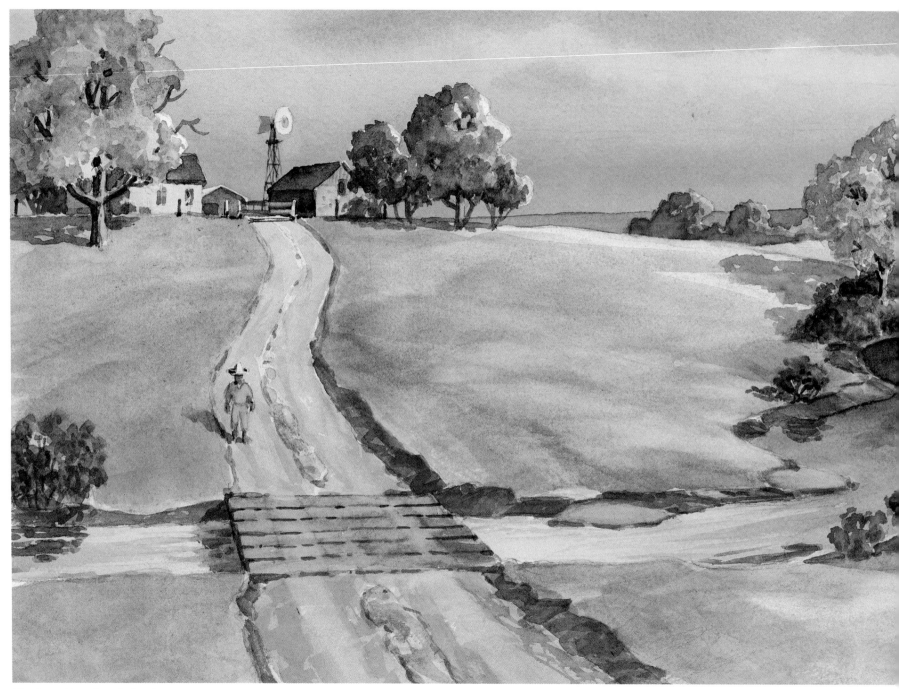

The Farm Near French Creek

A KANSAS FARM BOY

MY FIRST YEARS NEAR FRENCH CREEK

For those who envision Kansas as being flat as a pancake, my illustrations of the terrain around where I spent the first 5 years of my life should dispel that notion. I think it is again worth mentioning that photographs simply do not exist of this locale, except for a few of the barn at close range and the house at very close range. These did not provide enough information to compose a scene of the general area, so again I had to rely on memory.

The landscape bordering French Creek was indeed undulating and dotted with many trees. The stream had a sand and gravel bottom and was spanned by a wooden bridge, which was wide and strong enough to support vehicles and implements.

It was under this bridge that I became stuck one bright sunny day.

I don't remember it, but apparently I crawled under this bridge, which was no more than 18 to 20 inches above the water, and got stuck. Then I yelled and yelled and cried until help came. I have had claustrophobia ever since!

During periods of high water resulting from heavy rains, the road was obviously impassable. At those times, we had to make our way north to an improved road, which was some distance. As I recall, our conveyance was a spring wagon pulled by a team of horses since the route to the improved road (actually, a well-maintained dirt road) was too muddy to negotiate by automobile. In those days, horsepower was always a reliable form of transportation, and every farm had horses.

WANDERINGS

My wanderings were a source of anguish for my mother. She could not go out looking for me since she had to remain at home with my sister, who was 16 months younger than I. So she would call my grandfather, who was a retired farmer living in town, and he would get in his big touring car and come out looking for me. According to Aunt Dora, Grandfather would usually find me walking down a road some distance from home. I was always pulling my little red wagon, and my dog was often with me.

On one occasion, night fell, and I was still nowhere to be found. By this time, a search party had been formed. They finally found me under a haystack, fast asleep.

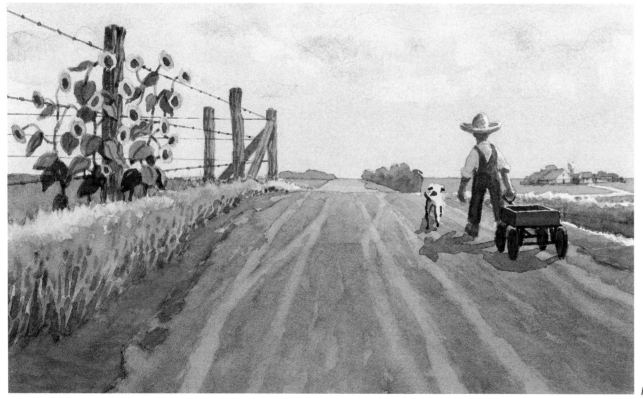

Heading Down the Road

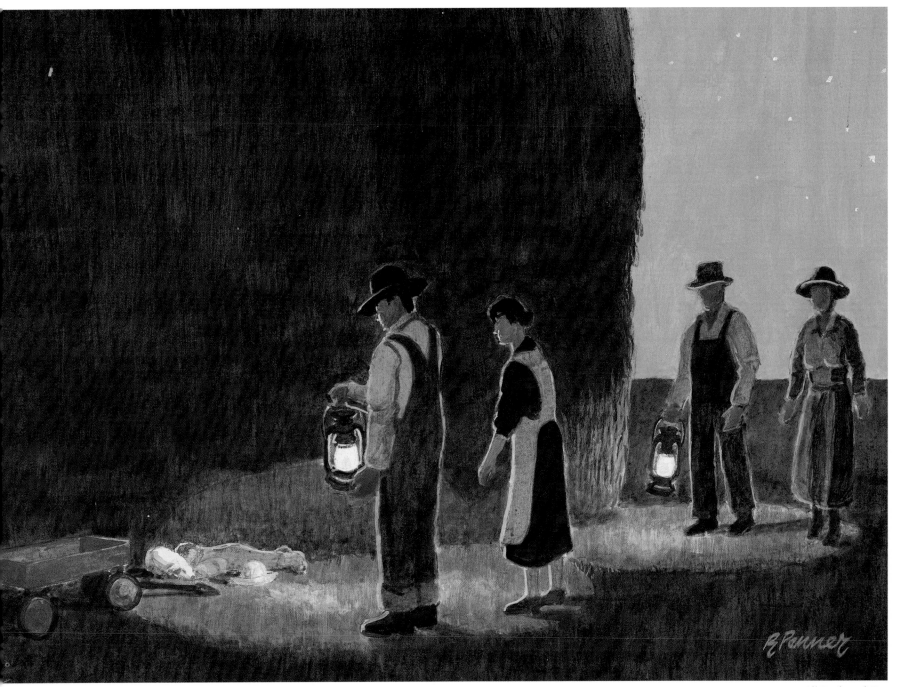

All Tuckered Out

ONE WINDY DAY

During Mother's illness, I spent a fair amount of time with Grandparents Riesen in town. One afternoon as they were taking me home, I lost my big straw hat.

We were driving through a draw, and just to the right of the road was a fair-sized pond. It was a windy day (not unusual for Kansas) and I was riding in the backseat of Grandpa's big touring car, a Buick. A gust of wind blew through the open windows and sent my hat sailing into the pond!

Grandpa stopped the car, and I went to retrieve my hat. I had to wait until the wind moved it to the opposite shoreline.

Out the Window

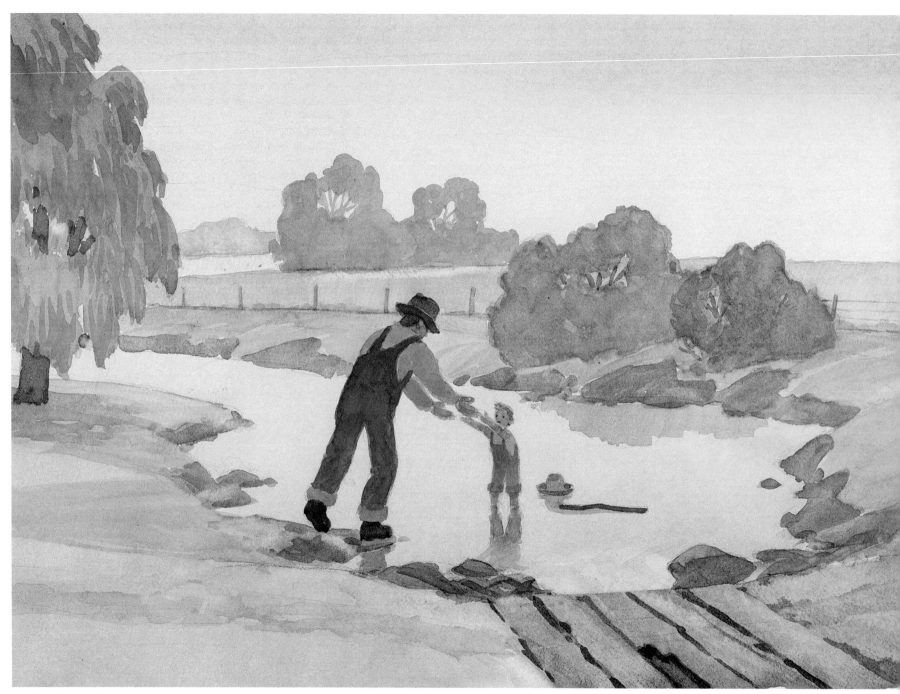

Stuck in the Mud

TAKING RISKS

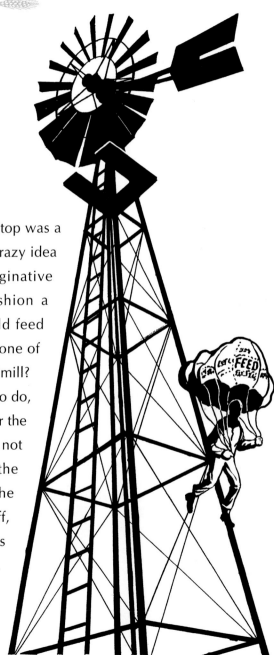

A former neighbor recently reminded me of an incident that I feel needs to be included here. The Bartels were our nearest neighbors when we lived on the north side of French Creek, and Norma still recalls my tendency to wander as a child.

One day, I was on my way to their place when I got stuck in the mud. The usual route took one across a culvert, which was the only crossing over the stream, and it seems that a stick I was carrying somehow wound up in the stream.

I became bent on retrieving it, whereupon I entered the stream with my trousers rolled up. Of course, the stick had drifted out to the widest and deepest part of the stream. I became mired in the mud and couldn't move. The Bartels heard me struggling and came out to investigate. Mr. Bartel pulled me out of my sticky situation.

I also remember being fascinated by the height of the windmill, and climbing to the top was a bit scary for me. A crazy idea came into my imaginative mind. Why not fashion a parachute out of old feed sacks and jump off one of the rungs of the windmill?

This I proceeded to do, and the day came for the test jump. No, I did not go to the top of the windmill! Well, the jump was carried off, but the landing was jarring, I must say. Luckily, however, no bones were broken.

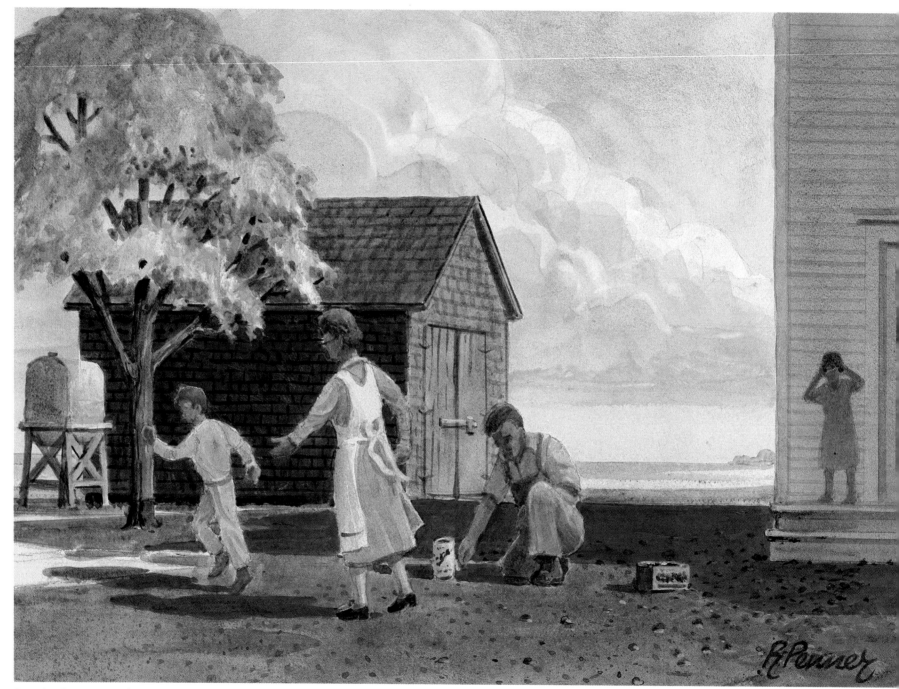

Running from Firecrackers

THE FOURTH OF JULY

One of the things I remember about the interim between Mother's death and Dad's remarrying was that Fourth of July. To dispel some of the gloom, Dad decided to celebrate with some fireworks. The Roman candles were fine, but when he got out some huge firecrackers, I wasn't too happy.

He would place them under a large tin can and light them, and the can would blow sky-high, just like a rocket. I wasted no time in hightailing it out of there. My aunt, Sister Anna Gertrude Penner, who had been given leave to stay with us, decided for some reason to run and catch me every time I made my exit. I must say she was fast on her feet!

Aunt Gertrude was with us from the time Mother's illness turned grave until Dad remarried. Being a registered nurse, she cared for Mother as best she could. In addition, she looked after my sister and me, as well as doing the cooking and the housework. Needless to say, she had a monumental task indeed, and through it all, she was pleasant and uncomplaining. She was a beautiful woman!

SPORTS & RECREATION

Just about the only time there was for recreation on the farm was on Sunday, or when it rained. Boys were put to work at an early age.

Probably the most common summertime sport in the country was baseball or softball. We almost always played on Sunday afternoons, much to the consternation of some parents. At least we weren't up to any mischief.

Pasture ball, as I like to call it, was usually played in cow pastures. No, we didn't use "cow pies" for bases. Instead, we used disks from a worn-out horse-drawn disk. These individual disks were heavy enough to stay in place on the ball diamond. They were shaped like a dish, with the edges snug against the pasture grass.

There were night games, which were played on a lighted diamond in Hillsboro. These night games were always league games. The teams in the leagues were either

The Old Swimming Hole

community or church-oriented.

Both baseball and softball were favorite sports of mine. I preferred playing first base and pitching. Being a tall kid with long arms helped considerably in both of these positions. I was also a switch hitter, being equally comfortable batting on either side of home plate.

I loved sports, and I guess that came from my dad. He was a letter man in college, lettering in baseball, football and basketball. In fact, he had a chance to play semipro baseball as a pitcher, but he wouldn't accept the offer because he didn't like the idea of playing for pay on Sunday.

Some older readers will remember the great screwball ace of the New York Giants, lefty Carl Hubbell. Carl had a brother, Jay, who worked in the oil fields near the Brudertal community. Jay was also an excellent ball player and often played on our team. Carl would visit his brother in the off-season.

We did our swimming in Spring Lake, which

was man-made, created by an earthen dam. Every bit of earth in the dam was put there by teams of horses pulling scoops manned by local farmers. You can imagine how many hundreds of dumpings by these scoops it took to build up the dam.

The lake provided a great place to swim and fish. It was there that I learned to swim. In the wintertime, we skated on the lake. We also played a rather improvised game of hockey, using tin cans smashed flat as pucks. Skates were mostly of the clamp-on type, with a hockey type blade.

There were also a few of what were known as Russian skates. The blade was curled up at the front and was imbedded in a wooden platform, which held leather straps to go around the toe of the shoe. The shoe had to have a leather heel to accommodate the screw on the heel of the skate platform. This style of skate was excellent for figure skating, and the few people who had them were highly proficient in their use.

Like many country boys, I ran a trap line during the winter months. The income from the sale of pelts was most welcome. I shipped my furs to a firm in Kansas City. Since a creek ran through our farm, that was where I did most of my trapping. I preferred going after muskrats, as they brought the best prices, and they were much nicer to handle in skinning and stretching. Stretching the pelt was done over an adjustable frame. I detested handling skunks and civet cats, and I don't have to explain why!

Sets for muskrats were usually placed under water, at entrances to their dens. This meant removing one's jacket and gloves or mittens and rolling up the shirt sleeve. Needless to say, it was a bone-chilling job.

The lowly opossum was the only other animal that wandered into my sets. In those days, the opossum was strictly a southern animal, its range never extending farther north than Kansas and Missouri. Today one finds them in the northern tier of the Midwest states, possibly because the winters have become milder.

Hunting and fishing were perfect outlets for a

Running a Trap Line

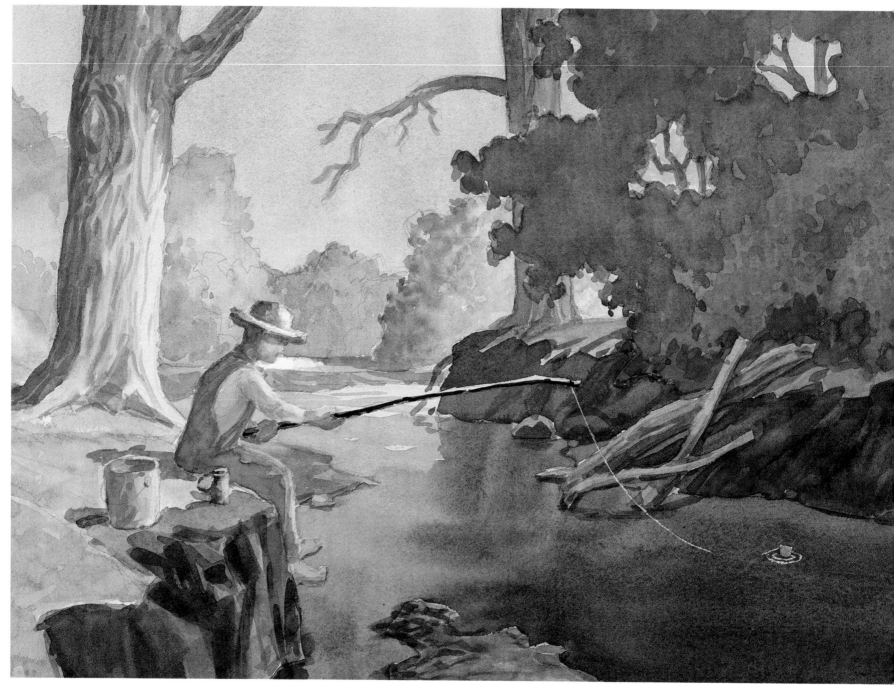

Fishing in the Creek

loner like me. Both activities were near at hand, living where we did. It wasn't until years later that I hunted and fished with companions.

Fishing was fairly good, although I never caught any lunkers. I used crawdads, minnows and angleworms for bait. The common bullhead was the most abundant fish, and you could always count on catching plenty of sunfish also. Other fish to be caught were bluegills, largemouth bass and, once in a while, a channel catfish.

Artificial lures and rods and reels simply weren't within the means of country boys. We used willow branches, saplings or bamboo poles as rods, and the line had to be purchased. For floats, we used corks.

When it came to hunting, it was all small game, except for the occasional coyote or varmints. I'll never forget the first time Dad sent me out with his old Winchester slide-action .22 rifle. It was on Thanksgiving Day, and I went into a pasture across the road from our farmstead. Suddenly I scared up a cottontail, and it took off behind me. I spun around, aimed and fired, and lo and behold, the rabbit rolled! Without a doubt, my first shot ever was the luckiest of all my hunting days.

My first gun was a Daisy lever-action air rifle, a popular boy's gun at the time. It was good for target practice, provided the target wasn't too far away.

Every farm boy remembers the first time he fired a shotgun. The recoil was quite a shock! Dad had an Iver Johnson 12-gauge sin-

gle shot, which was kind of a standard gun on the farm. Dad's shotgun had a habit of losing its forearm grip when fired. The barrel would dislodge from the grip, which stayed in my grasp.

When I got a little older, I purchased a Stevens .22 bolt-action single-shot rifle with money made from fur sales. Hunting cottontails in the wintertime was a source of income, meager as it was. I sold them dressed to a few people in town, with my dear grandma being my best customer.

I also had a unique method for catching snapping turtles. After a heavy rain, the creek would rise and the water would back up

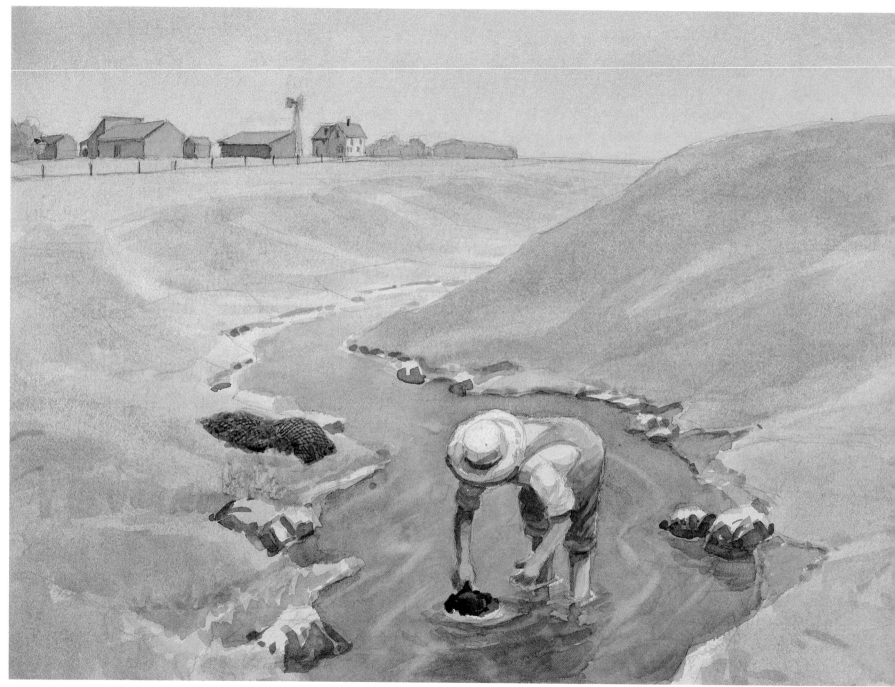

Catching a Snapping Turtle

into the ravines. Creek creatures followed the flow of water and wound up in the ravines. When the water receded enough to wade, I would go in barefoot and search for snappers with my toes.

If I determined that it was a turtle, I reached into the water and felt around the shell until I located the tail. I then hauled the turtle out and deposited it in a gunnysack. I caught a lot of turtles this way, including some very large ones, and never once was bitten on the hands or toes. Apparently I was lucky!

———◦◦◦◦———

Walking on stilts was a fun thing in which many farm boys indulged. Stilts were easy to make from two-by-fours. I made up a pair and enjoyed showing off for my sisters by displaying my skills at walking on them without falling. It was exhilarating to be able to walk tall. That was something that girls never tried, as I recall.

Probably the most popular form of lawn recreation was croquet. Almost every farm family had a croquet set. One didn't have to have an area of grass to play on, just so the court was reasonably level.

Pitching horseshoes was strictly a man's game. I well remember learning to throw an open shoe, which meant that ringers were a sure thing, provided the shoe was thrown directly at the stake.

Indoors during those long winter evenings, checkers, dominoes and Chinese checkers were all popular. There were also simple card games, like Rook.

Another thing I remember well was the roller skating rink at Marion, the county seat some 10 miles east of Hillsboro. Roller skating was a favorite activity for many of us boys.

I can still recall the gentleman who was the proprietor. That man could actually dance on roller skates like nobody I'd ever seen.

DIVERSIONS

I remember my "percussion" instruments. They were empty oil drums with the open ends on the ground. In the evening, after the chores were done, I would go to my oil drums behind a shed at the far north end of our farmyard.

This shed was well removed from the house, and I don't need to tell you why. I would beat out melancholy rhythms, my own interpretations of the blues, or "rhythm and blues", shall we say.

I have to admit I got a certain satisfaction out of spooking the farm animals at times. (Boys will be boys, you know.) It was a way of creating some excitement. Hogs spooked quite easily, but it was the cattle who took the prize, especially if there was a cow or two in the herd that was especially jittery. I remember a brindle cow that would stampede at the drop of a hat.

On a nice quiet summer evening when all the cattle and horses were settled down in the corral, I would approach with my jacket or shirt raised over my head and make weird noises. Suddenly the really jittery cows would take off for the corral gate, which was open, and then all the other cat-

tle and horses would follow. There was the thundering of hooves, and everything was immersed in a huge cloud of dust.

It was a rather naughty thing to do, to be sure. It was one of those crazy pranks that farm boys were prone to, but there was never any damage to anything or anyone.

To get relief after a hot, dirty day of work, I fashioned a shower of sorts. I put nail holes in the bottom of an old bucket and nailed the bucket to the side of a small grain shed, high enough to get under it (and all out of view from the house!)

I then pumped ice-cold water from the well into a couple of buckets, carried the water to my "shower", put a bucket of water in the bucket and enjoyed the refreshing rush of **COLD** water.

I took great pleasure in "high jumping" fences, especially to impress my sisters. One time I didn't make it and was well lacerated by the barbed wire, which happened to be rusty. Was I taken to town for tetanus shots or stitches? Heavens, no! Rather, I was subjected to derisive laughter, and I had to live with my wounds. I bear the scars on my legs to this day.

HOMEMADE TOYS

Young farm boys played at what they were most familiar with, which was farm activities. As often as not, they had to create from scratch the various toys to simulate the actual object. There simply weren't that many toys available in those days. The most common were cast-iron tractors and trucks.

All I had was a tractor that was a rather poor replica of a Fordson. Too bad I don't still have that toy tractor, for it would be worth something today. In fact, that goes for a lot of the objects we took for granted in those days. Whoever would have thought it back then?

When threshing season came, I was inspired to play threshing. I had the tractor, but not a toy threshing machine, so I fashioned a rather crude one with materials available. I used a piece of four-by-four lumber with a piece of two-by-four nailed on top. A piece of pipe served as the blower, and I used thread spools for the wheels. It certainly wasn't a very good model of a threshing machine, but materials were limited. My imagination filled the void created by the missing parts.

———

I think a lot of boys tried building their own airplanes, crude though they were. With my interest in aviation, I also created contraptions that bore some likeness to aircraft.

Wings, tail, wheels and propeller were all simulated. I built a number of these "homebuilt" aircraft and each one became a bit

My Homemade Plane

more sophisticated. The basic materials and tools were at hand, and I simply had to use my imagination.

I clearly remember buying pulp magazines at the drugstore and reading them over and over again. All of them were about avia-tion, and the majority were about the flying done in World War I. One of these "pulps" featured a hilarious series about an aviator named Phineas Pinkham. *Flying Aces* was another magazine I especially enjoyed.

Cutting It Close

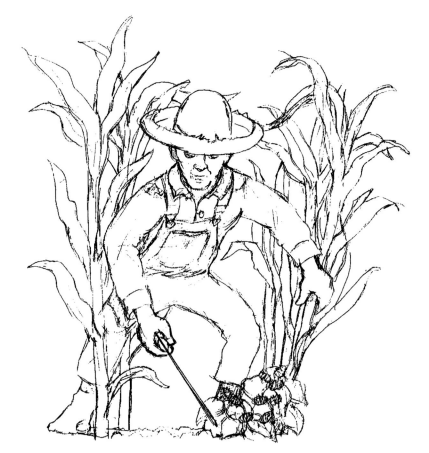

As I've already mentioned, I loved to take risks, not realizing at the time how serious the consequences could be. One of the crazy things I remember doing was tearing through farm gates (open, of course) with a team of horses pulling a dump rake.

As many of you farmers know, the width of a dump rake is not much less than the width of a farm gate opening. You can imagine what would have happened had one of the wheels caught a gate post!

Fortunately, I never had the misfortune of finding out. I like to think that I was a pretty good judge of distance, but probably I was just plain lucky.

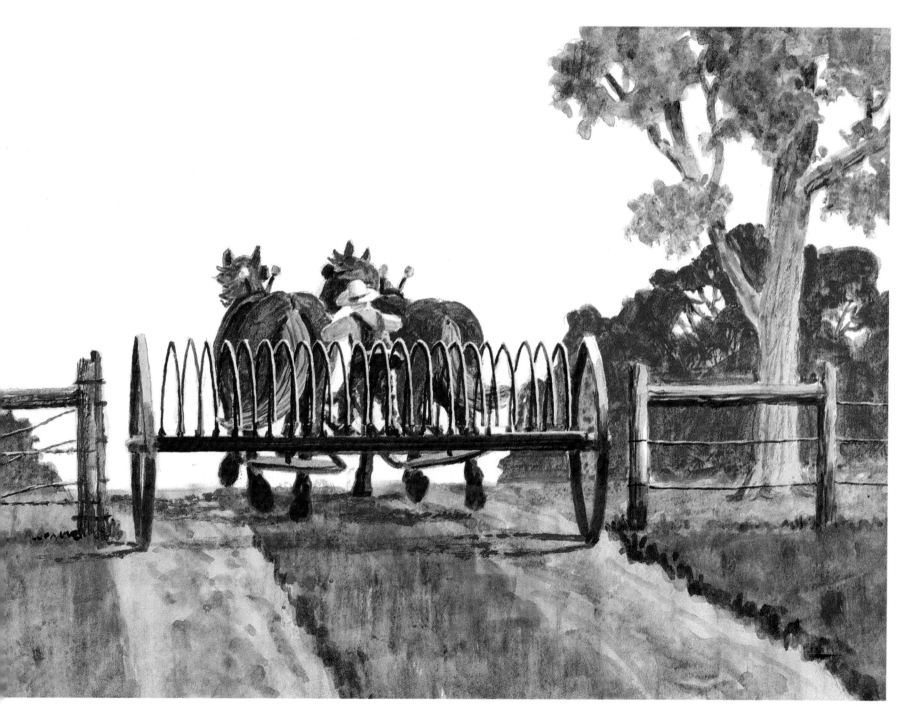

A Tight Fit

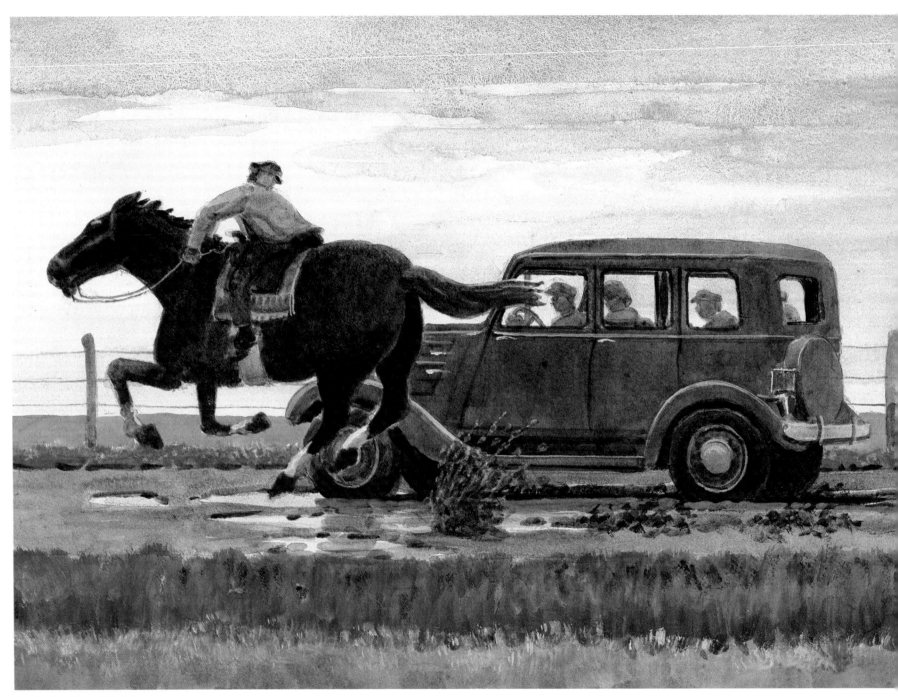

My Indian Pony "Lindy"

LINDY

My personal mode of transportation for many years was an Indian pony named "Lindy", and a flying fool was he. Coal black with a white star on his forehead and white feet, he was also a real character.

Everywhere I went was on horseback: high school, church, town and visiting. When I rode to town, I kept my horse in the small barn in Grandmother's backyard.

The first year of high school, which I attended in the town of Hillsboro, my transportation was by horseback, a distance of approximately 3 miles. What I especially remember about those rides was the way Lindy delighted in passing cars on days after rains had turned the roads into mud. The sticky, clay-like gumbo soil would clog the rear wheel wells, and drivers had to use a crowbar to dislodge the stuff. This made for rough going by automobile.

My many trips on horseback often meant having to return home at night. Nightfall can create strange silhouettes that spark the imagination of boys and horses. My Indian pony was spooky enough in the daytime, but after dark, his imagination ran wild.

We would be riding along at full tilt when suddenly he would think he saw something threatening and would just as suddenly sidestep with a jolt. This would occasionally throw me out of the saddle, but somehow I always managed to hang on to the reins. It would have meant a long walk home if I hadn't!

A night ride that I often made was returning home from Uncle Adolf's, where I had gone to listen to *Gang Busters* on Saturday evenings. We didn't have a radio at home at the time. A fellow my age lived with Uncle Adolf, and the two of us listened with rapt attention to the daring-do adventures of the G-men. That was a 3-mile ride each way, and on a dark night, it could be a bit hair-raising, especially on such a skittish horse.

CHURCH DOINGS

Church attendance was a must for us children, no questions asked. And as with most kids, having to go to church wasn't exactly a highlight of the week for me.

We did get to see our friends there, and I especially remember the times I was invited to go to a friend's house for dinner. Often it would be for supper as well, and then we would go back to church for Junior C.E. (Christian Endeavor) in the evening, from whence I would accompany my family home.

I recall that this particular friend would sometimes forget to take off his work shoes before going to church in the evening. Prior to evening services there were chores to do, of course, which included milking and slopping the hogs. Some of the milk and slop would wind up on the shoes, along with manure. Needless to say, this combination wasn't exactly Chanel No. 5. It produced quite a noticeable odor, especially within the confines of a church.

Another thing I remember about church was the segregated seating arrangement. On one side (the left side, as I recall) sat the women, including young girls. Up front, in the far left corner and near the pulpit, sat the elderly ladies. Opposite them, in the far right corner, sat the elderly men. This arrangement for the elderly was to make for better hearing of the sermons—if they didn't fall asleep!

Oh yes, there was a small room in the back of the church on the women's side for new mothers and their babies. Unruly youngsters were also taken there, as well as crying babies. If worse came to worst, the miscreants were taken outside the building.

The seating arrangement for the males was such that we boys were under the surveillance of the men. If there was untoward behavior on the part of us boys, the men would reprimand us. One thing I remember that we boys did and got away with was our ingenious method of consuming peanuts during church. This would take place the morning of Christmas Day.

We had gotten our bags of goodies after Christmas Eve services the evening before. The bags contained nuts and hard candies. There were also those terribly sweet chocolate drops, equally sweet "orange slices", walnuts, Brazil nuts and peanuts. Before leaving for church on Christmas morning, we would place a fair number of peanuts in our suit coat pockets, along with a jackknife in the pants pocket. During services, we would ever-so-carefully split the peanut shells with the jackknife to eliminate any noisy cracking of the shells.

Christmas Eve services were a delight for the adults, especially for the parents whose children participated in the programs. They thought it was cute to see those little kids try to recite their lines, all the while being ill at ease. There were exceptions, of course, and

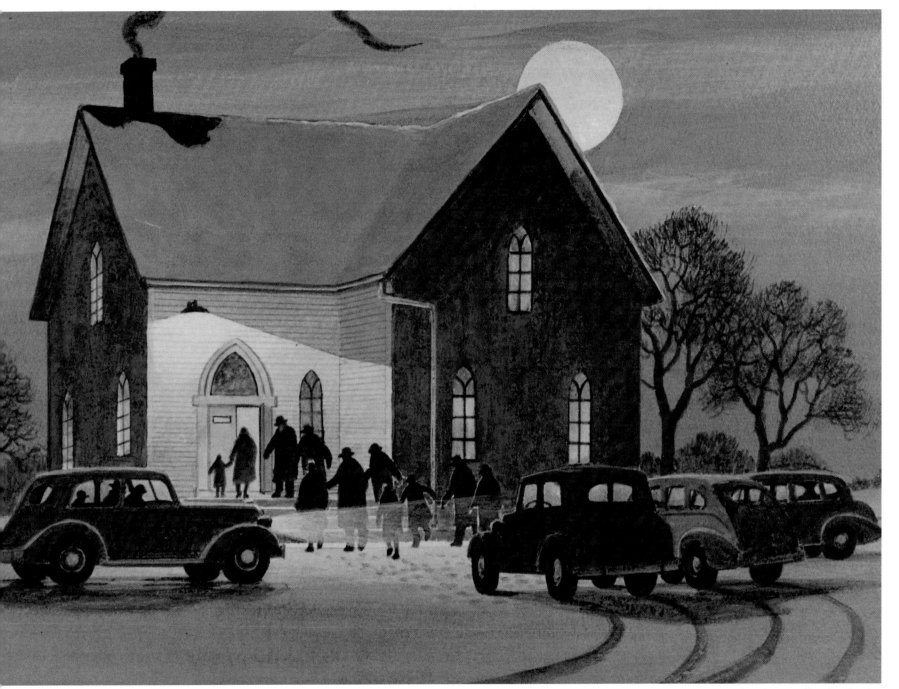

Evening Service

I guess I was one of them. I actually enjoyed taking part in skits and plays.

There was always a large Christmas tree, well adorned with ornaments and real candles. To see the many candles glimmer on a large tree is a long-gone sight. Buckets of water were kept nearby, just in case there was a fire.

The first years I remember in church were when the sermons and hymns were still delivered in German. I recall vividly the highly emotional sermons delivered by Reverend Goerz. Reverend Mouttet was more low-key. Reverend Arnold E. Funk was the pastor at the time I left the community, and for some time before that.

We kids always looked forward to the church picnics in the summertime. Long tables were heaped with scrumptious food of all kinds. There would be homemade ice cream, watermelons and crullers, which went with watermelons like butter on bread. (Crullers are deep-fried batter, much like Indian fry bread.)

There was recreation associated with these picnics, too. Horseshoes were a must, and perhaps croquet, as well as baseball or softball out in the pasture.

During the early years, people came to church by horse and buggy. Even when cars became common, adverse weather and bad roads often necessitated travel in the old reliable way. A long stable in the back of the churchyard housed the horses during services. That building remained standing as long as I can remember, even long after I left home.

I got in on the tail end of the Model T era. There was one late model that stands out in my mind's eye. I can still see it leaving the churchyard with an old couple aboard. It was a black sedan with a definite list. This was caused by the fact that the missus (a term I haven't heard for years) was of very large proportions. On the other hand, her husband was a small lean man. His wife rode in the backseat, in the corner opposite the driver. Needless to say, the vehicle developed a permanent droop on the side where she sat.

Model T

Cows in the Pasture

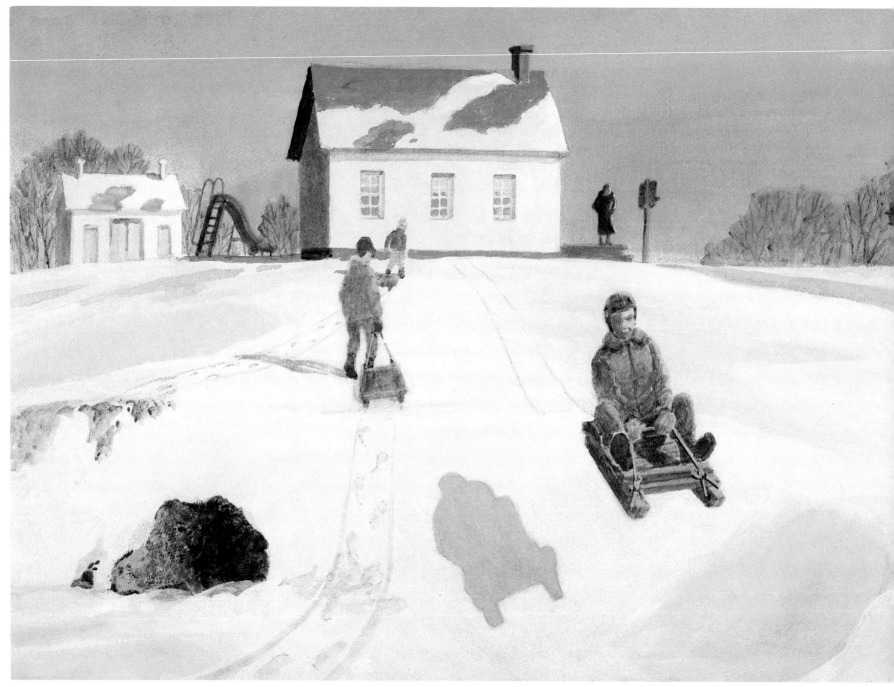

Sledding at School

SCHOOL DAYS

There was, of course, no such thing as kindergarten in those days, certainly not in the country schools. I started attending school at the age of 6. Lighthouse District 78 was a typical rural one-room school with one teacher for all eight grades. There were usually only a few students in each grade, but not all grades were represented every year. We had individual desks.

During my 8 years attending Lighthouse, I had three teachers. They were Adele Lichti, Bertha Unruh and Benny Goossen. In reflecting back on those years, I wonder how they ever managed to pack all the responsibilities they had into a day of teaching. After all, it wasn't only teaching, but janitorial duties as well. During the fall and winter, they arrived at school early in order to start the fire in the coal-burning stove to have the building reasonably warm by the time the students arrived. This stove was at the rear of the schoolroom. A hall, just inside the entrance, ran the width of the building. It doubled as a cloakroom.

Study aids were limited to a rather meager library as measured by today's standards. We also had an encyclopedia and a rotating universe with the world globe, sun, moon and primary planets.

One of the disciplines that was taught in those days was the Palmer method of penmanship. I clearly remember the handbook of exercises that were carried out with pen and ink. The idea was to improve everyone's handwriting.

It amazes me to this day that the teachers managed so well. They obviously had to be well versed in the three R's. They had to be able to handle discipline problems, although I cannot recall anything even approaching the problems one hears about in today's schools. There was respect for the teachers, just as there was respect for parents in the home. Oh yes, another thing, the boys took off their caps *before* they entered the schoolroom.

I understand that there are still a few one-room schools in operation in some states. Bless the teachers!

We always looked forward to recess time. The playground consisted of a slippery slide, teeter-totter, merry-go-round and a basketball court with goals. We enjoyed a variety of games, none of which required much, if anything, in the way of equipment. There was that old game of crack-the-whip, handy-over with kids on both sides of the schoolhouse tossing a rubber ball back and forth over the building, work-up softball with players advancing in position with each out, and knock-the-tin-can. When we had snow in the winter, we played fox and geese, went sledding and built "igloos".

Lighthouse School was situated on a rise, with the greatest

slope to the west of the schoolhouse, down to the north-south county road. We were indeed fortunate to have a slope on the school yard, because the general terrain of the area was flat. This made for good sledding and digging caves into the steepest part of the hill, which was about halfway up the slope. These caves, which we dug in the spring and fall, were excellent jump-over points for our sleds.

Our sleds were homemade. Making one's own sled was no great task. All that we needed was some lumber, nails, a length of rope and some pieces of scrap iron. The latter was usually obtained from the top edges of old wagon or buggy boxes, which already had holes for nailing to the bottom edges of the sled runners. This made for faster sledding, and speed was a priority with boys.

There was a line of trees at the bottom of the hill, with intermittent stumps where dead trees had been felled. This made for even more excitement, the challenge being to avoid the trees and stumps, or getting stopped before reaching them.

We had several school programs, with the Christmas program being the major production of the year. These were always special. The plays that were part of the programs required many re-

hearsals, all of them supervised by the teacher. Of course, there was normally a student or two who would forget his or her lines while on stage, and the teacher was off stage behind the curtain to act as prompter. These affairs were well attended by people in the community.

At home, I studied by lantern light in my room upstairs. This was hardly adequate lighting for reading, but I managed. Actually, I read more than just school textbooks, probably too often neglect-

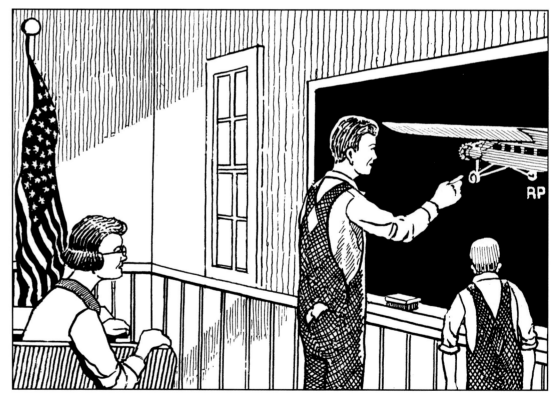

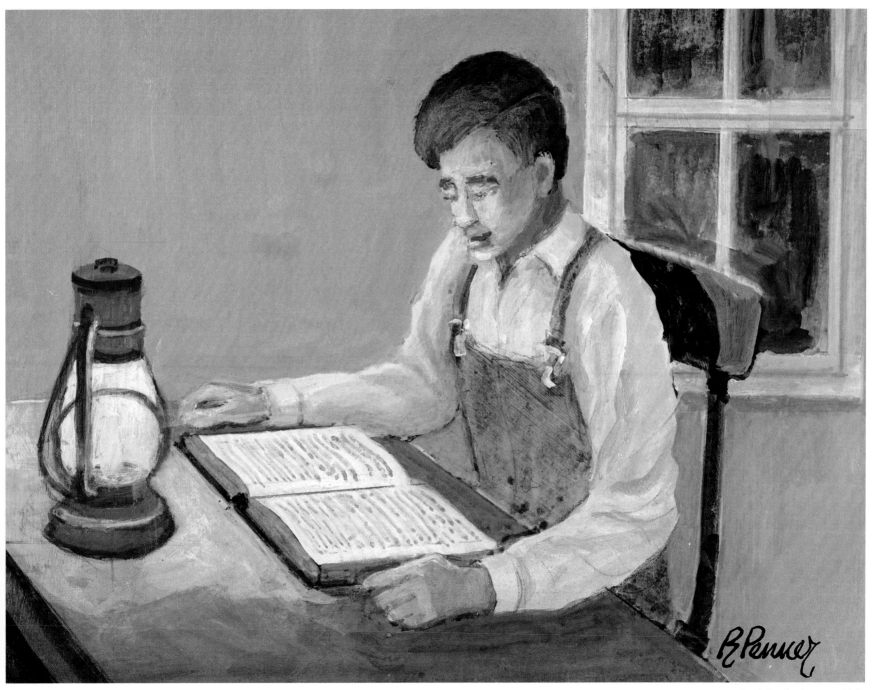

Studying by Lantern Light

ing schoolwork. I remember poring over *Field & Stream* magazines that had been given to me by a friend, Waldo Nickel. I dreamed of someday catching a muskie, which I eventually did on a fishing trip to Canada in 1948.

As with many individuals who went on to become professional artists, I did a lot of drawing when I was in grade school. Blackboards lined both side walls in our one-room country school. I recall drawing all manner of things in chalk on those blackboards. Probably the thing I drew most was airplanes, especially the Ford Trimotor.

I would also draw on paper, even brown wrapping paper. Artist pads were unknown to us then, as were many of the artist's tools and materials that are taken for granted today. I well remember trading drawings with fellow students for their apples, oranges and other contents of their lunch boxes. Fresh fruit was a rare thing at our house.

Whenever any artwork was needed in school, I was the one who did it. I recall that one year there was a competition among area country schools for displays that were set up in a spacious building in town. My job was to draw, color and cut out likenesses of people who were in the various professions represented in Hillsboro. I don't recall how our school came out in the judging, but I do remember that one particular likeness I created was quite accurate. It was of Pete Hiebert, who was the area trucker. He drove a Reo truck.

When I entered high school, my drawing continued. Whenever any drawing was involved in class work, I was in my element. During what was called study hall, I would be found drawing instead of studying. For some reason, I was not reprimanded very often.

⸺⊰◦◦◦⊱⸺

We sometimes had blizzards that left the roads impassable. At these times, the mode of transportation best suited to the conditions was the horse-drawn bobsled. I recall that the Bartels, our neighbors, had a bobsled. Their children attended the same grade school as we did, and Mr. Bartel would stop and pick us up since we lived on the route to school. Away we would go, snugly settled on top of straw and under horse blankets.

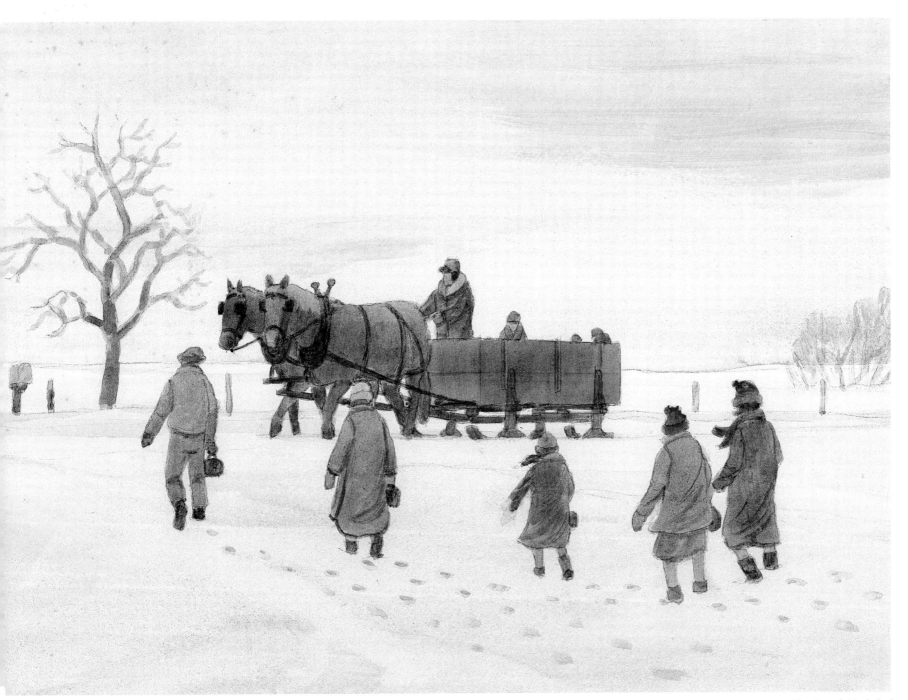

The Bartels' Bobsled

MISS LICHTI WRITES...

I began attending school in 1927, which, coincidentally, was Adele Lichti's first year of teaching at Lighthouse. I remember that I was quite fond of her, and "Miss Lichti" remembers me as an "easy learner". I was delighted to be able to get in touch with her after all these years.

Now Adele West, she is 87 and still going strong. She has lived in California since 1932 and has been widowed twice. Her first marriage was to Herman Schmidt in 1929, after her second year of teaching at Lighthouse. Worth mentioning is the fact that she went before the school board with her marriage plans.

Married women teachers were uncommon in those days, and Miss Lichti wasn't about to be fired for "getting hitched" while teaching. Fortunately, the school board gave her their blessing.

Adele West has vivid memories of her years teaching at old Lighthouse District 78. She shared some of those memories with me, and I, in turn, would like to share them with you. With her kind permission, I am quoting directly from her letters. I think you will find her comments quite interesting.

"I taught at Lighthouse School from 1927 until 1931," she writes. "I did not have all eight grades in any one year, usually four or five grades. The school year began in September and ended in May. School began about 8:30 and ended at 3 o'clock.

Adele Lichti (above) began her teaching career at Lighthouse School in 1927, the same year the author first attended school. At right, Miss Lichti poses with Peter Knaak, one of her strapping eighth-grade students at Lighthouse.

"I shook down the base burner stove when I arrived about 7:30 and added coal. By the time the children arrived, it was almost warm. A typical day began with the Pledge of Allegiance, a Bible story, a song or two and then classes. Everyone was given an assignment to

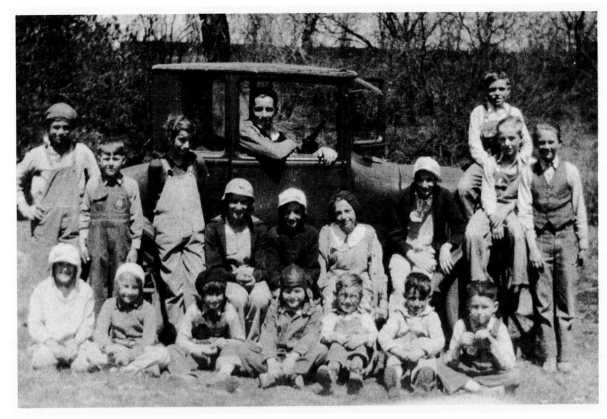

The end of the school year was celebrated with a picnic. Randy Penner is standing at far left; his sister, Hilda, is standing third from left. Benny Goossen, a later teacher at Lighthouse, is behind the wheel of the Model T.

class, we sat at your desk. Each year, the county held competitions in Marion, the county seat. We participated in spelling, music and recitations.

"My salary was $75 a month. I paid $20 for room and board, 50 cents a week for my laundry and $25 a month on my school debts, but managed nicely. My salary increased $5 a year. My fourth year, I earned $90 a month. School was seldom canceled except in blizzard weather.

"We did not have electricity, phones or running water. A bucket and dipper on a bench in the hall, a pump in the yard and little houses in the far corners of the yard completed our facilities. We celebrated Halloween at school, had a Christmas program to which we invited parents and observed Presidents' birthdays.

keep them busy, with intervals for helping those who were working alone. All grades were taught reading, spelling, arithmetic and writing.

"The older children added history, geography and language. We had a recess about mid-morning and a lunch hour from about noon till 1 p.m. Classes were held on a bench near the teacher's desk or wherever it was convenient. If you were the only one in a

"We did not have evening programs because we had no lights! If we could not spend recesses or part of our lunch hour outdoors, we often had a short lunch hour. Fathers arrived early if the weather was bad and we dismissed school early."

What a remarkable memory! I am indebted to Adele for this insightful vision into the past.

ICE STORMS

There were a few ice storms in our area that were especially severe. Everything was covered by a thick coating of ice, so much so that some of us skated across fields to school.

Obviously, this made it treacherous to get about and was very hard on livestock. One of our cows took a nasty fall and was unable to get up. We finally got her up and into a nearby shed.

Dad fashioned a sling for around her belly, and with a block and tackle, we raised her up into a standing position. The poor cow suffered for a time, and unfortunately, we finally had to dispatch her. I'm sure a vet would have diagnosed her as having a badly broken hip.

Blizzards weren't much better. Sometimes the snow would fall so furiously that just getting from the house to the barn, or vice versa, became a real challenge.

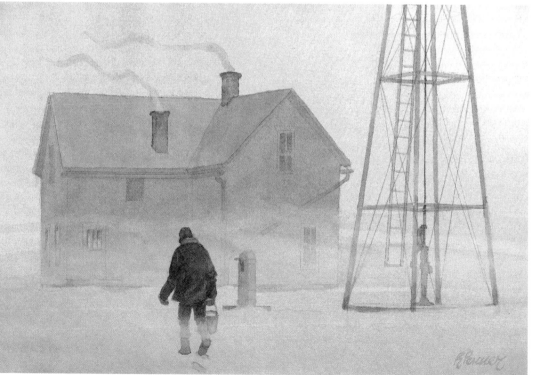

Walking in from the Barn

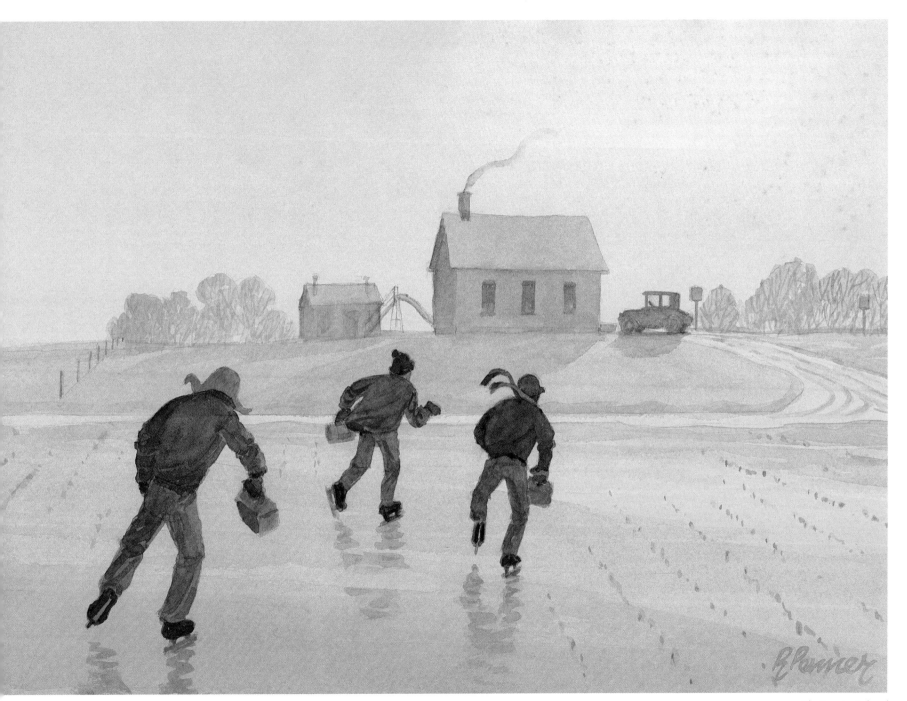

Skating to School

An Easter Snow

I remember one Easter Sunday when we went to my grandparents' in town by spring wagon and team. Yes, the spring wagon had springs to cushion the ride. It was considered a light buggy with no top.

Taking the car was out of the question because there had been a snowstorm the night before, leaving deep drifts in some sections of the roadway into town. We avoided these areas by going across fields and pastures and through farm-field gates.

This made for a very roundabout journey, but Easter had dawned bright and clear, so the buggy ride was a pleasant trip. However, hunting Easter eggs outdoors at Grandma's house obviously was not possible. A sumptuous meal made up for that!

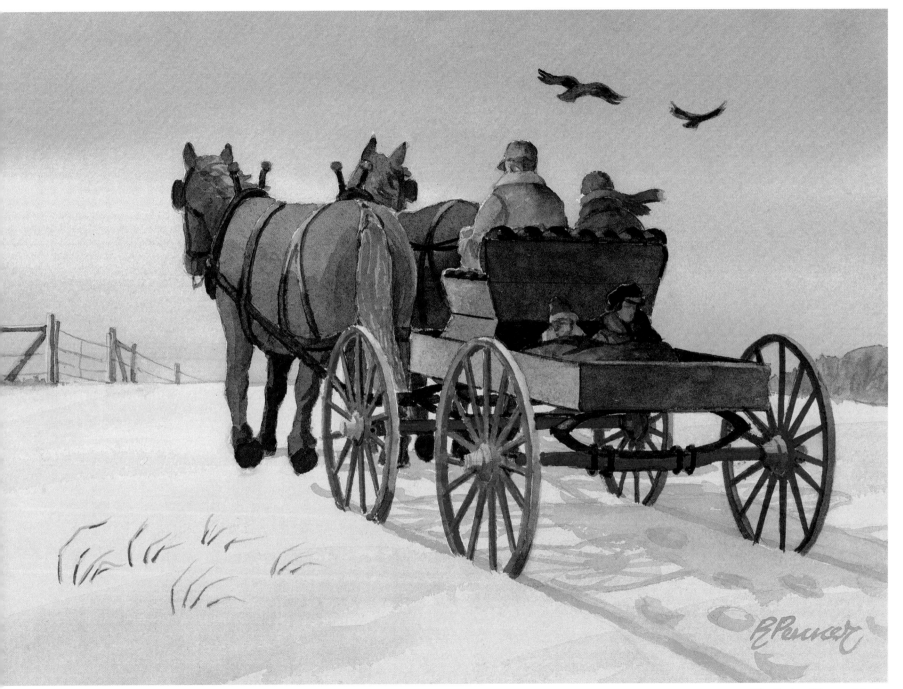

The Spring Wagon at Easter

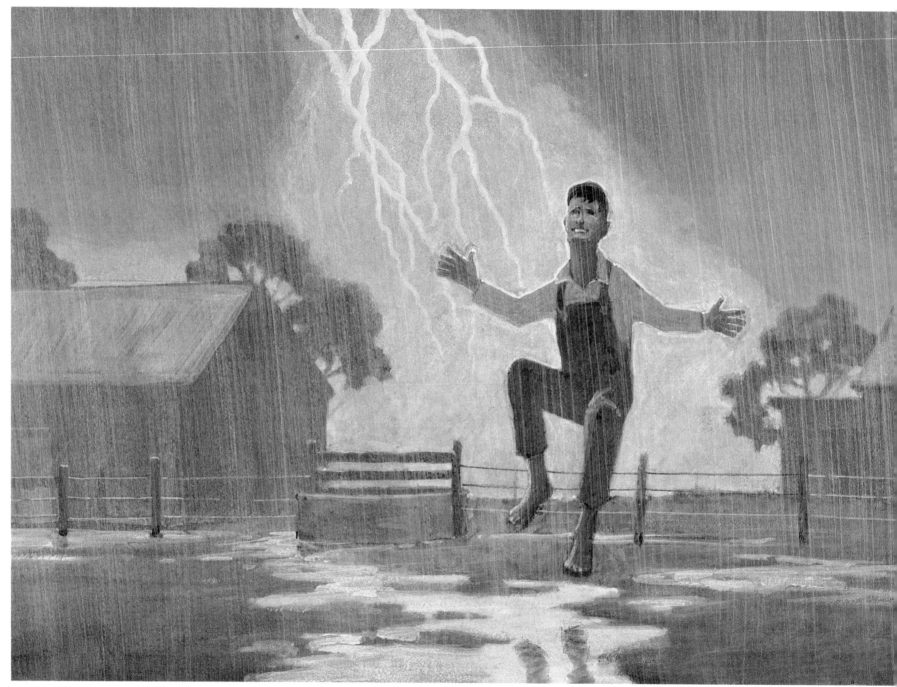

Rain Dance

THUNDERSTORMS

I loved the drama of thunderstorms, probably because it was a relief from hot dry weather, even though momentary. When a thunderstorm approached, I would try to be outside. I'd remain outdoors through all the thunder and lightning and getting soaked when it rained.

During the dry years, there would be a lot of noise, but sometimes only sprinkles from those ominous clouds. This was a common occurrence, and very disappointing for the poor farmers.

Quite often, tornadoes were spawned by thunderstorms, but in all my years in Kansas, I never even saw one form. I did see the aftermath of what these twisters left in their paths, the terrible destruction and the crazy things that happened, like straw driven into telephone poles.

Not long after we moved to Wisconsin, I finally had a chance to see a funnel cloud in all its stages, from formation to touching down to dissipation. The awesome power of nature has always fascinated me.

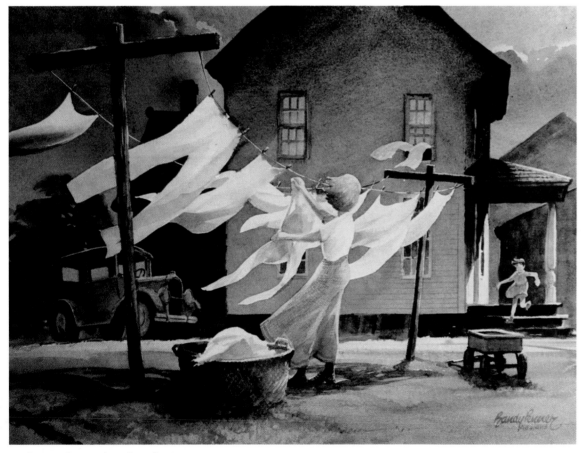

Gathering the Wash Before the Storm

DUST STORMS

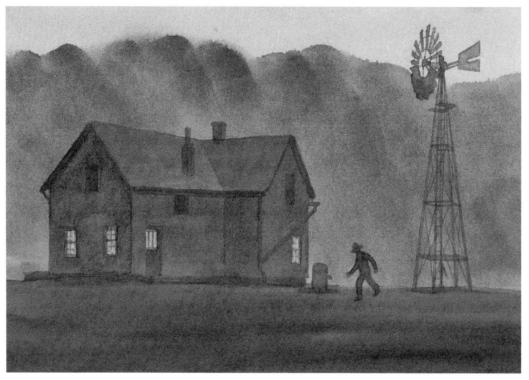

Hurrying Home

Dust storms came with the drought. The day would start bright and clear with no wind to speak of. Suddenly we would see a brown mass rolling in, hence the name roller.

These rollers usually appeared on the western horizon. It was time to prepare for almost total darkness! Children were let out of school to get home ahead of the dust cloud. Men came in from their fieldwork. Activity all but stopped. Drifts of dirt formed everywhere, especially where there was any kind of obstruction. Fencerows were often all but invisible, and anything standing out in the open was pretty well buried.

The dust filtered into and through everything, which made it miserable for the housewives—there was simply no way to keep everything clean.

I well remember one particular day in grade school when a roller came in. It was noon recess and we were playing out in the school yard. We saw the telltale brown cloud hugging the earth on the far western horizon, stretching from south to north. Soon the cloud of dust was upon us, and teacher got us all inside the schoolhouse. It wasn't long until day turned into night.

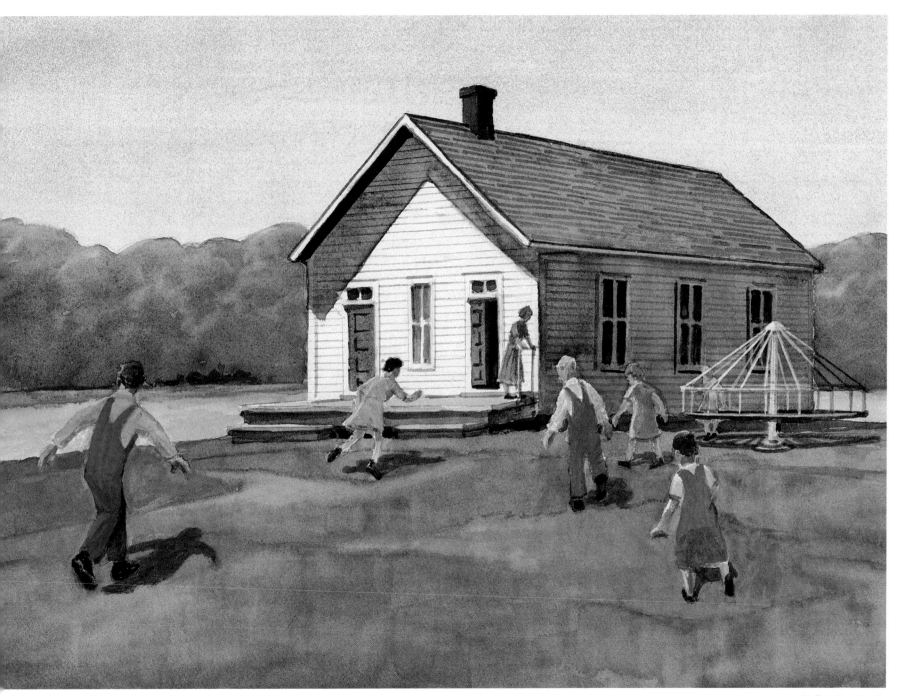

Roller Coming in

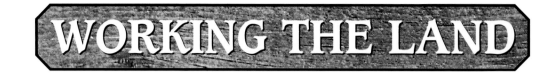

WORKING THE LAND

CHORES

One of my least favorite summer tasks on the farm was chopping down cockleburs and sunflowers in the cornfields. This was done when the corn became too tall to cultivate, and long before any farmer ever heard of pre-emergence and post-emergence herbicides. I was armed with what was called a corn knife (actually, a machete).

Cockleburs were the peskiest of weeds. I well remember how the burs would cling to the ends of horses' tails, actually creating a ball at times. This certainly did not aid in the horse's use of its tail for flailing away at the flies. It is said that the poisonous seedlings of the cocklebur can kill hogs and young cattle.

Spring on the farm was the time for fixing fence, a job that Dad and I did together. Depending on how much of a job it was going to be, we would either take a team and wagon, or walk the fence line. The wagon carried the replacement posts and rolls of barbed wire.

Chopping Cockleburs

Fixing Fence

Tools required included a wire stretcher, of which there were several types. Ours was the old-fashioned rope type. It was used to pull the wires tight before splicing and nailing to the fence posts. A

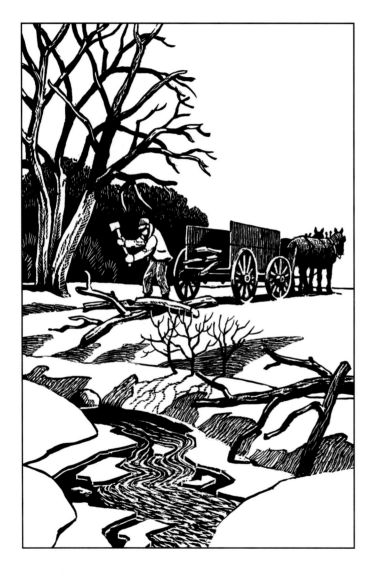

special kind of pliers, which we used for both cutting and twisting the wire, was needed, as well as a claw hammer and staples.

A necessity was sturdy leather gloves, without which one could not handle barbed wire, especially when it came to splicing. A post-hole digger was carried along in case posts needed replacing. We also carried a short pole that was used to tamp down the dirt as we placed it around the post. It was narrow enough in diameter to go between the post and the outside perimeter of the hole. An iron bar was also used for this purpose.

Since wood was one of the fuels burned in our heating and cooking stoves, it was my job to gather it from trees along the creek. There were always enough dead trees to provide dry wood. I would take the team and wagon, along with an ax and saw, and pretend I was a lumberjack.

I remember the ax was a Plumb, one of the popular brands of that time. Dad and I went out together at times, especially when the trees were large enough to require the use of a two-man saw. The stove-length pieces then had to be split with an ax, and that was a job I dearly loved.

The various kinds of wood we used were cottonwood, elm and box elder. Osage orange, or hedge wood, as it was usually known, was also used as firewood, but one had to be careful with it because it burned very hot. It was the longest burning of any of the woods.

It is an extremely tough wood and was (and perhaps still is) used for fence posts.

———— ◦◦◦◦◦ ————

There were chores to do both morning and evening. Farm kids where I grew up were involved in feeding the livestock, and it was actually a fun job. It meant close contact with animals, and you know how kids love animals.

The boys were responsible for the livestock, while the girls took care of the chickens, which were Buff Orphingtons. There were Duroc hogs to feed, as well as cattle, including calves.

Milking was done in the evening, and it was done by hand. On a cold day, it

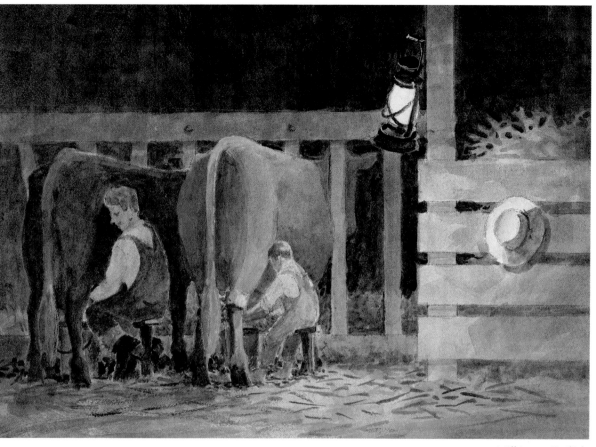

Milking at Twilight

was nice to be next to the warm body of a cow. Some cows were kickers and had to be hobbled in order to get the milking done. When milking was done, and the cows were let out of the barn, we occasionally would forget to remove the hobbles. It was quite a sight to see a hobbled cow go hopping along. Usually the hobbles would finally fall off on their own.

The cows we had were Milking Shorthorns. They weren't the milk producers that dairy cattle were, but then, we were not in the dairy business. The Milking Shorthorn doubled as a good beef animal.

The horses were usually mixed breeds of the draft type. They were generally not showy animals. Of course, some farmers did have purebred horses, and they were the ones exhibited in the horse barn at the county fair.

Separating Cream

Cream separators were a part of almost every farm household, since most farms had milk cows. By far, the most common make of separator was the DeLaval.

Centrifugal force from turning the crank helped separate the heavier, richer cream from the skim milk. The spinning action was imparted by a hand crank, and there was inertia to overcome when starting to turn the crank. This job fell to the kids in the family, and I frequently performed the task.

The skim milk, often mixed with ground grain, was fed to the hogs. Whole milk, saved for family use, was not run through the separator.

The cream was kept in a cool place which, in the hot summertime, was the well. The cream can was lowered by a rope into the well and left hanging just above the water line. Butter was also kept cool in that manner.

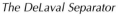

The DeLaval Separator

A Grinding Task

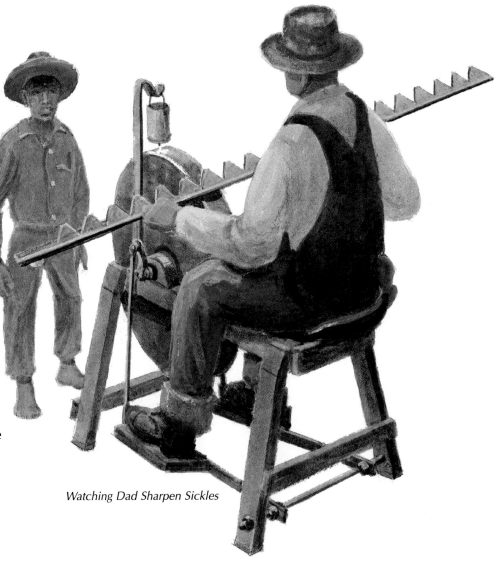

We had a big foot-powered grindstone that sat near the garage under a tree, which afforded shade during hot summer days. Dad used it to sharpen the individual sickles on a sickle bar, which was the "cutting edge" of a mower or grain binder. It required some leg muscle to get the circular grindstone turning because of the inertia, but once it was turning well, the pedaling was easy.

It wasn't until I was older that I was able to operate the grindstone. For one thing, my legs had to be long enough to reach the pedals; and also, the sickle bar was rather heavy. Then there was finesse needed to do a good job of sharpening.

To keep the grindstone wet for the sharpening operation, an arm extended up alongside and over the top of the grindstone. From this was hung a tin can with a hole in the bottom and a shingle nail suspended in the hole. The shingle nail had been used to make the hole, and with the shingle nail in the hole, the water in the can dripped out in a small steady stream.

Watching Dad Sharpen Sickles

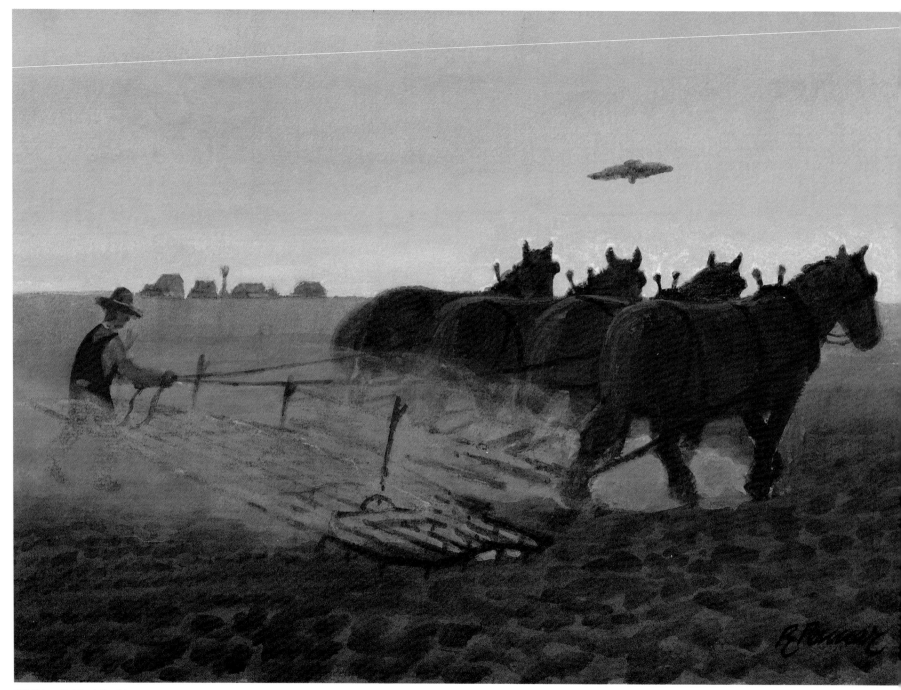

Walking Behind the Harrow

FIELDWORK

All of my early fieldwork was done with horses.

Fieldwork involved many phases. To begin with, there was plowing, followed by disking and then harrowing to prepare the soil for seeding of small grains.

Harrowing was done in two ways. One either stood on boards laid across the harrow sections, or walked behind. The walking method meant miles and miles covered in a day's work. (I wonder what today's joggers and speed-walkers would think of that kind of exercise!)

In preparing for corn or sorghum planting, the soil did not have to be as fine. The idea of disking and then harrowing was to break the clods down to soil that was not too coarse in consistency, thus giving the small grains a better chance to sprout.

Corn, sorghum and any other legumes, such as what we called sugarcane, were planted in the spring. We also sowed Sudan grass, which was used for cattle feed. Sudan grass was a crop that grew tall and looked much like thin cane. It was sown with a grain drill and harvested much like hay and fed like hay.

We also raised winter wheat, so-called because it was sown in the fall and sprouted before winter set in. Turkey red wheat was grown almost exclusively in our area and, in fact, over much of Kansas. It is a very hardy winter wheat that was brought over from Russia by the Mennonites when they migrated to America.

My home community was settled by some of these very same Mennonites, including my grandparents. The farmers farther north sowed their wheat in the spring because the winters were too severe, and the wheat would have been frozen out.

As the season progressed and our corn developed and grew tall, the fields were cultivated in order to keep the weeds under control. The spades of the cultivator obviously could not get at the weeds in the rows of corn, so it was the children's job to walk the fields row by row and pull the big weeds.

Operating the cultivator demanded full attention all of the time. Foot pedals regulated the position of the spades to keep the spades from digging out the cornstalks. We also steered the horses, although they pretty much refrained from knocking down the corn plants.

The corn planters and cultivators were either single or double row. A team of two horses pulled the single-row implements, whereas three or four hitched abreast would pull the double-row machines. It was single-row units that I worked with.

Oh, how the mind wandered when spending endless hours be-

hind horses! One dreamed dreams, looked into the future and pondered the whys and wherefores. And there was singing as well, though it was a long way from being operatic. There were the old Western ballads, like *Home on the Range*, and believe it or

Dad

not, I even taught myself to yodel!

It wasn't until I was into my teens that I worked with a tractor. Dad bought a Farmall F-12, the smaller version of the famous Farmall series manufactured by IHC (International Harvester Corporation).

Farmalls were the most popular row-crop tractors. The rear-drive wheels were adjustable for width and the front wheels were close together, thus allowing one to work crops planted in rows. Dad traded some of our horses, including my Indian pony, as part of the deal. We still kept a team on the farm for the numerous operations that horses did best, however.

When cultivators were tractor-mounted, the added height of the row-crop tractor meant that the crops could be fairly tall before they couldn't be tilled any longer. John Deere came out at about the same time with what they called their general-purpose tractor, the Model A. This was also a row-crop tractor. Allis-Chalmers and Case then came along with their versions.

The most common tractors in our area were the McCormick Deering 10-20 and 15-30, and later, the IHC F-20 and F-30. Then there was the John Deere Model D and later, the Model B. There were a few Massey Harrises, but I recall only one or two Minneapolis-Molines and one Wallis.

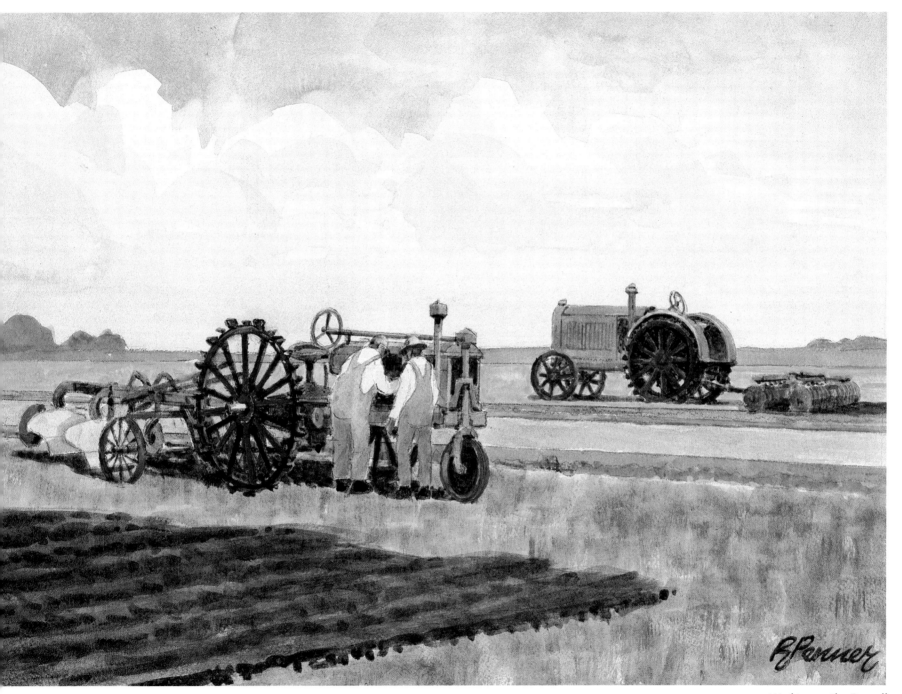

Working on the Farmall

HARVESTING CORN

Cornhusking was done by hand. This was a rather long and tedious operation, as every ear of corn had to be removed from the husk, which then remained on the stalk. We wore cotton gloves for husking and to get longer wear from them, we coated the palms and fingers with pine tar. A husking hook was strapped on one glove (on the right glove for right-handed persons) and the hook was used to strip the husk from the ear, whereupon the ear was broken from its stem and tossed into the wagon.

The wagon had a "bangboard" on one side of the wagon box against which the ears were thrown. The ears would then fall into the wagon box (the same principle as the backboard in basketball). A special end gate on the wagon, easily installed and removed, facilitated emptying the wagon by pushing or dumping the corn ears out the rear.

Corn ears were by no means as easy to shovel as small grains. The ear corn was put in corncribs or granaries. The next step was shelling it, and there were custom corn shellers who made the rounds of the farms with their machines, which were operated by a tractor's power takeoff. The cobs from the shelling operation were saved and burned as fuel in cookstoves. Not all the corn was shelled. Ear corn was fed to the hogs. Some of the shelled corn was coarsely ground to serve as chicken feed.

Corn was also harvested with a corn binder. Ours was a single-row, horse-drawn machine. As with small grains, the corn bundles had to be placed into shocks. This was no easy task because of the size and weight of the individual bundles. Corn harvested in this form was primarily used as feed for cattle. The stalks and leaves provided roughage, and the corn ears were consumed whole, cobs and all.

Some farmers had corn pickers, a mechanized version of cornhusking. Most of the pickers were single row.

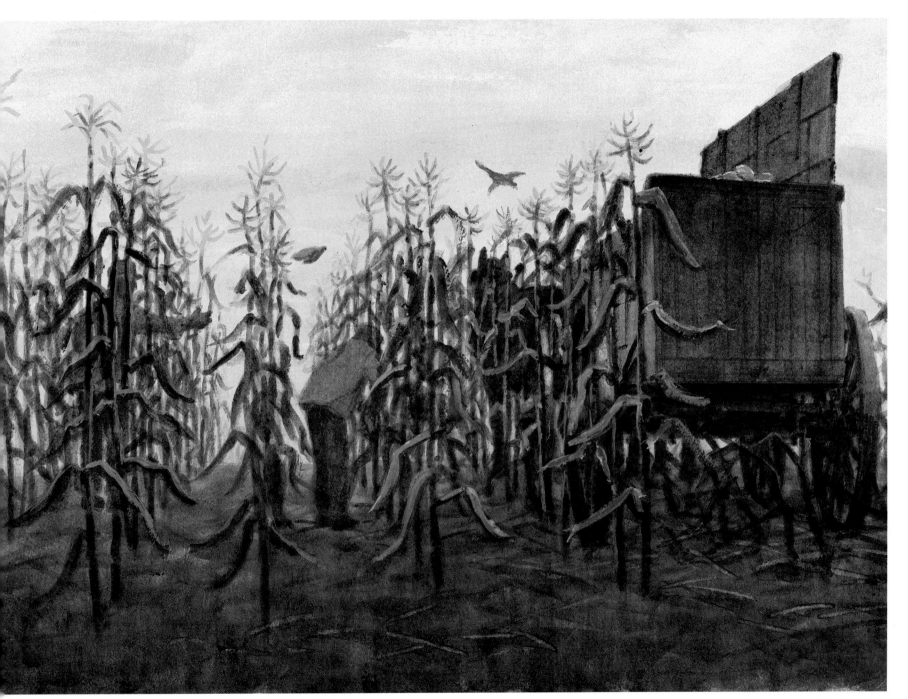

Husking Corn

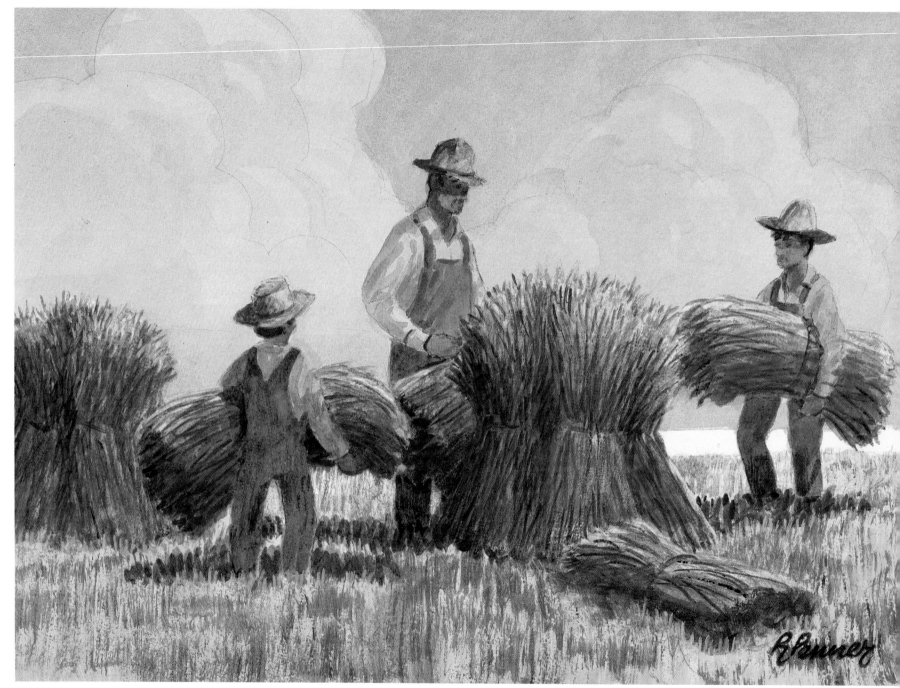

Working Together

SHOCKING SMALL GRAINS

Wheat, oats and barley were the small grain crops we raised. Small grain harvest started with binding and shocking. Combines were not as yet part of the farm machinery inventory.

Harvesting started with the horse-drawn binder, which formed the cut grain stalks into bundles. The bundles dropped into a carrier when bound, and when the carrier was full, the operator tripped the carrier to dump the load of bundles on the ground. The bundles were dropped into rows.

The bundles were then formed into shocks, which is where I came in. We formed our shocks with 8 to 10 bundles in a shock. Laying a bundle across the top of the finished shock was something we never did. This was done more in areas with more rainfall.

Shocking was usually the job of the youngsters on the farm, although adults would also get involved, including the womenfolk.

I remember vividly one hot summer day when Dad, my sister and I were shocking barley in a field in the northeast corner of our acreage. We talked of many things as we were shocking. It was good for the three of us to be together.

Barley was absolutely the worst grain to handle. It was those long scratchy beards on the heads that made barley so itchy and scratchy. Long-sleeved shirts were a must, believe me! Socks were out of the question because the beards would lodge in them.

Even worse than shocking was stacking the straw as it came out of a threshing machine's straw blower. I had to do that once for a neighbor, and to make matters worse, it was a miserably hot day. When the day's work was finally over, I made a beeline for home and my homemade shower. The ice-cold water straight from the well was glorious relief!

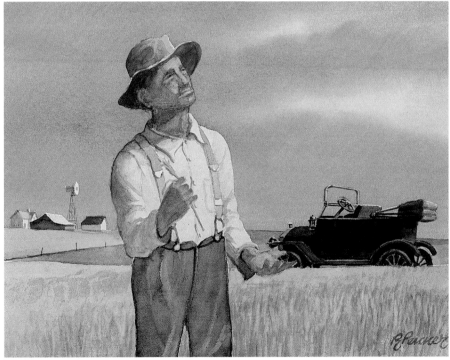

Waiting for Rain

HAYING

There were two types of hay on our farm, virgin prairie and alfalfa. Being native, prairie hay didn't have to be sown. It was a very tough grass that could survive adverse weather. It was primarily fed to horses. Alfalfa was a perennial legume that was far more succulent than prairie hay. It was seeded once, then harvested and re-harvested again and again in one growing season from year to year. It was great hay for cattle.

The haying began with mowing. Unfortunately, this crippled wildlife from time to time, because animals and birds failed to get out of the way of the cutting sickle. Rabbit's and bird's nests were sometimes exposed. This happened most often when cutting prairie hay, as it was taller and denser than alfalfa. Prairie grass also harbored bumblebee nests, and woe be to the horses that stumbled into a nest while pulling the mower! Many runaways resulted from this encounter, since the horses would bolt trying to get away from the swarming bees.

After the hay was cut, it was left where it fell until it had dried enough to rake, which is where the dump rake came into play. The rake tines, or teeth, picked up the loose hay. When the rake was full of hay, the operator would trip a foot lever, which raised the set of tines and dumped the load of hay, thus the name dump rake. Rows of hay were formed this way.

When the stacking operation got under way later, the buck rake (we often called it the "go-devil") was used to gather the hay for transport to the stacker. It literally bucked into the rows of hay until it had a load, thus the term buck rake.

Stacking hay was another event on the farm that required "outside" manpower, unless a farm family was large enough and the children old enough to handle all the various operations necessary to create the stack. It required someone to operate the buck rake, which brought hay in to the stacker from

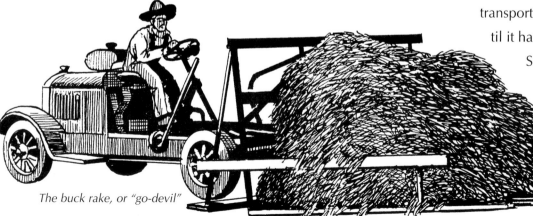

The buck rake, or "go-devil"

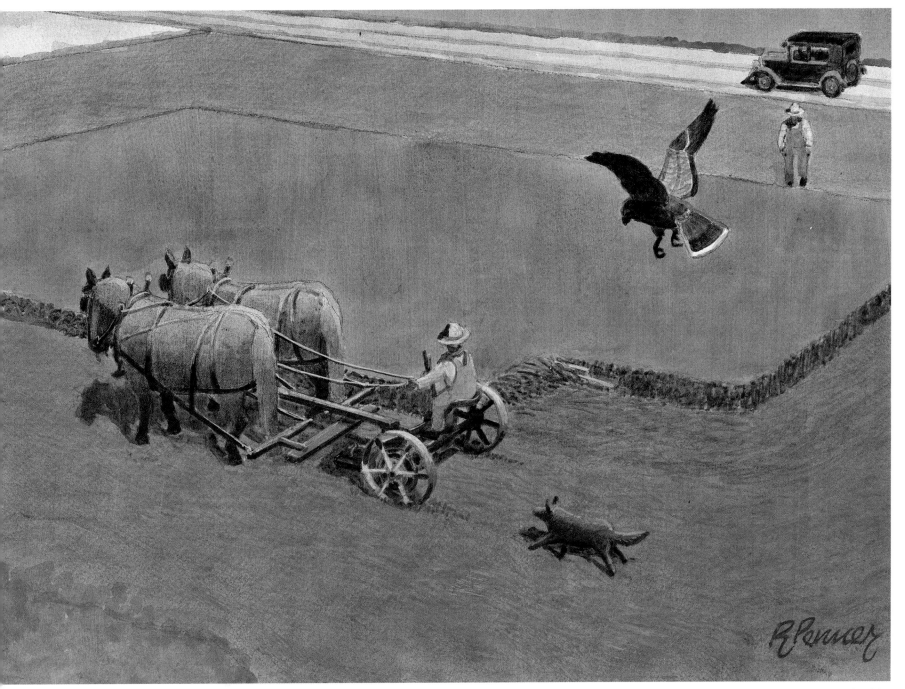

Mowing Hay

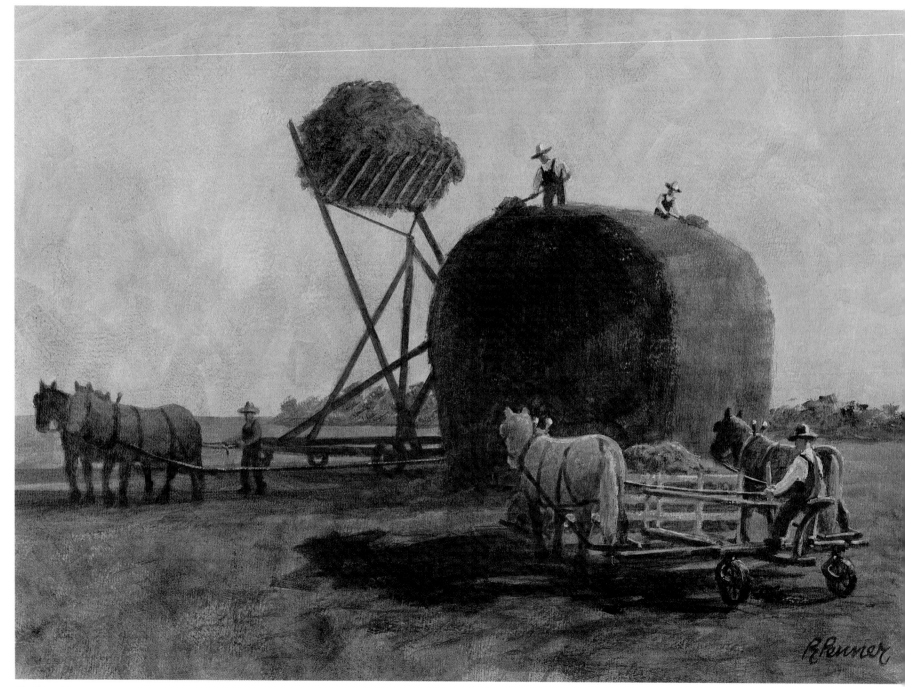

Stacking Hay

the rows of dried hay in the field. Another person on the dump rake, which had formed the rows initially, would gather the loose hay that the buck rake had left. Someone had to operate the stacking machine, and yet another individual had to drive the horse or the two-horse team pulling the heavy hay rope that lifted the hay boom up and onto the stack. Two men on the stack did the forming with hayforks, a job strictly reserved for adult men.

Stacking could also be done in a simpler fashion, although it meant more work. A hayrack with a two-horse team and driver went alongside the rows of hay in the field and two men with hayforks pitched the hay onto the rack. When full, the hayrack was driven alongside the stack site. One or two men on the hayrack pitched the hay from rack onto the stack. One or two men on the stack distributed the hay around to form the stack. As the stack built up in height, it meant the men on the rack had to toss the hay higher and higher until the stack was topped off. The stacks were almost always rectangular in shape.

Most barns had haylofts, into which hay was pitched from racks coming directly from the field. The larger barns had hay slings, which made getting hay into the loft much easier. The sling worked from a track that ran the length of the barn just under the roof peak. There was an extension of the barn roof over the hayloft door to facilitate getting the hay up out of the rack and into the loft. Long grappling hooks, or arms, opened over the load of hay on the rack and then closed to lift the hay from the rack and thence into the loft.

Baling hay actually came later during my stay on the farm. I do remember the baling of straw, and this was a stationary operation with the baler next to the straw stack. The straw was needed for animal bedding, especially during the winter months.

What are my recollections of haying? I was involved in every facet of the haying operation, but the hardest part by far was the actual stacking. One had to work fast to stay ahead of the stacker, yet carefully, because the stack had to be properly shaped. There was a ladder at one end of the stack for the stackers to ascend and descend during the course of building the stack. Lunch in the shade of the stack was a most welcome respite.

THRESHING

There was a romance about threshing time, even though it was a lot of hard work.

Three different small grains were threshed: wheat, oats and barley, with wheat being the principal crop. A threshing ring was composed of a number of farmers who contracted with a custom thresher who owned the tractor and threshing machine. There were nine individual farmers in our particular threshing ring.

The threshing rig moved from farm to farm, which often took quite a bit of time as those big tractors did not have a road gear. The distance involved in these rings was usually not more than 3 to 5 miles between the farms. The move was made late in the day or early in the morning, so as not to cut into the long day of work any more than necessary.

Each member of the ring would man a bundle rack, going from farm to farm each morning to load and pitch bundles. If there was heavy dew, work couldn't start too early because the threshing machine wasn't able to do a thorough job of separating the kernels from the chaff because of the moisture.

The threshing machines I pitched bundles to were 36-inch machines, among the largest machines made. (The largest were 42 inches.) The 36 inches was the width of the "maw" into which the bundles were fed. The tractors were huge and powered by a variety of fuels. If they were burning kerosene or distillate, they were started with gasoline. They were lumbering giants with big wide steel wheels.

The tractor operator was most often the owner of the rig. The duty of the separator-tender was to keep the machine greased and oiled and running trouble free. He also adjusted the straw blower to keep the straw stack forming properly. The spike pitcher assisted on the bundle racks when they were unloading at the feeders. He also kept the area around the feeder clear of bundles that fell off the racks or were misthrown.

Also involved with the threshing operation were the horse-drawn grain wagons and the bundle racks, also called wagons. The farmer at whose farm the threshing was being done was responsible for supplying the grain wagons. The grain was hauled to grain bins (granaries) that were located in the farmyard. The straw stacks were usually near the farm buildings so that straw was nearby for use as bedding for the farm animals. Oat straw was also used for feed.

One of the nicest things about the threshing season was the meals, always appreciated by growing boys and hungry men. There was a big breakfast, a mid-morning lunch, a big dinner, then the mid-afternoon lunch and, of course, a sumptuous supper. You can imagine how much work this was for the ladies.

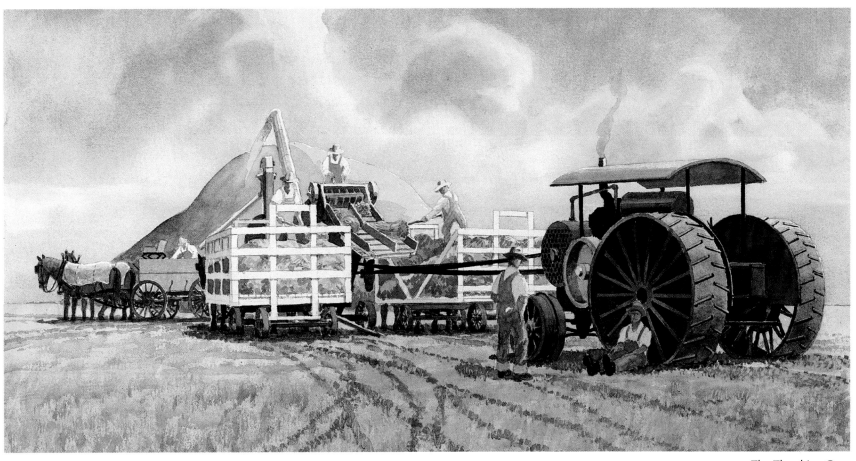

The Threshing Crew

Lunches were brought to the threshing site by the women. Meals were sit-down in the farmhouse. Benches were placed outside the house, with basins, soap, water and towels for the sweaty men to clean up before eating. Combs were laid out as well.

I began pitching bundles when I was 14 years old, and trying to keep up with the grown men was no easy task. On a 36-inch machine, there was a split feeder upon which the bundles were pitched from the rack, with a rack on each side of the feeder. The bundles had to go into the feeder grain end first, otherwise the machine would jam. Believe me, those were hungry machines!

When the day's work was finally over and it was time to head for home, I would lie down on the floor of the bundle rack and let the horses pretty much find their own way, except for guidance at road intersections.

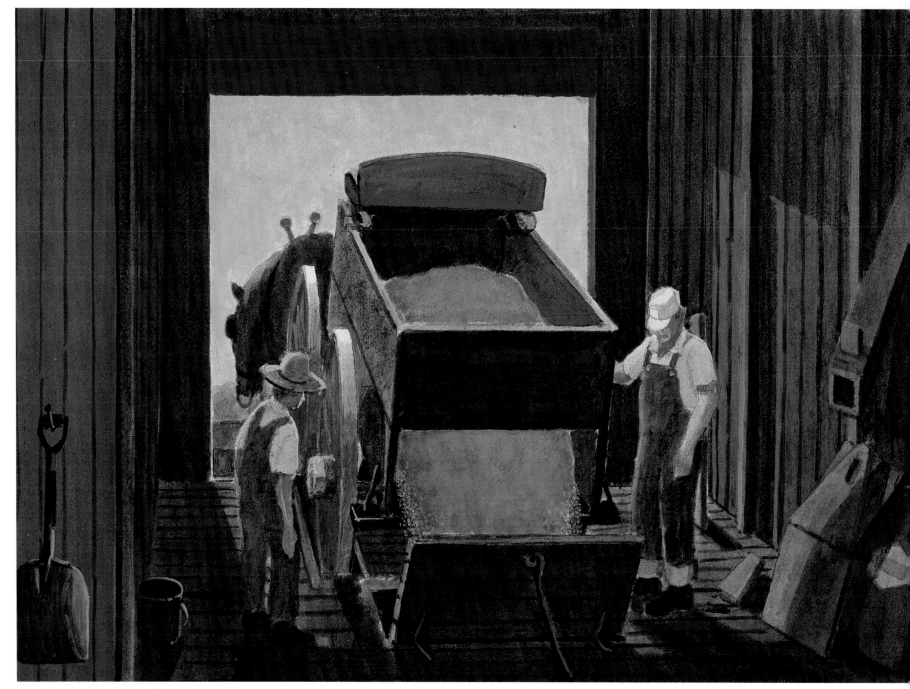

Wagon Dump

OTHER FARM DEVICES

During the harvest or any time Dad wanted to sell a wagonload or more of grain, I would often have the job of taking the team and wagon to the elevator in town, 3 miles away.

There were several types of wagon dumps. Some were hydraulically operated, while others were electrically activated. The one I was familiar with was pretty basic, using the fulcrum principle. The wagon dump in the Hillsboro Farmers Cooperative, where we took our wheat, operated on a simple fulcrum principle. A few farms had their own wagon dumps that functioned in the same manner.

The wagon was driven onto tracks, which tilted like two teeter-totters set alongside each other. When the wagon was in position, the trap door to the grain pit was opened. The wedge-shaped pin located at the base of the dump lever, which kept the lever in locked position, was removed. This allowed the back end of the wagon to tilt downward.

This, of course, brought the front end of the wagon up, and with it, the wagon tongue, along with the hitching unit for the horses (double and single trees). My old neighbor tells me we usually left the horses hitched during the dumping opera-

tion since the hitching assembly didn't rise all that much (only 3 to 4 feet).

The lower end gate on the back of the wagon was removed and the grain spilled into the pit. When all the grain had slid out of the

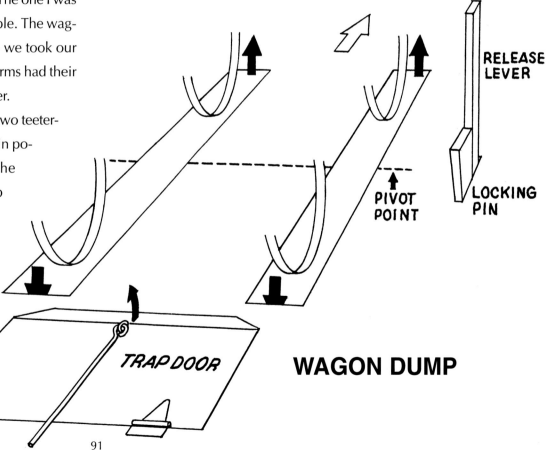

RELEASE LEVER

PIVOT POINT

LOCKING PIN

TRAP DOOR

WAGON DUMP

wagon, the horses were driven forward, thus returning the tracks to level. The locking pin was replaced and the trap door closed, and the dump was ready for the next wagonload of grain.

———————

Stationary engines were to be found on a number of farms. They were "one lungers" (one cylinder) and came in all sizes and horsepower. The smaller engines, in the 1/4 to 4 hp range, were the most common. They were used for grinding grain, pumping water and other farm jobs. I remember seeing them on four-wheel carts so they could be moved to different jobs.

They were also mounted on saw rigs on both the rotary and cross-cut types. One fairly large engine I recall was the one in Uncle Adolf's granary. It was used for transferring grain to and from a number of grain storage bins within the granary.

There were two types of these engines. One was operated by throttle control, but the most common type was the "hit and miss" because it did not fire on every stroke of the cylinder. The demand power system was controlled by a governor. The transfer of power to whatever the engine operated was by belt drive from the pulley, opposite which was the flywheel.

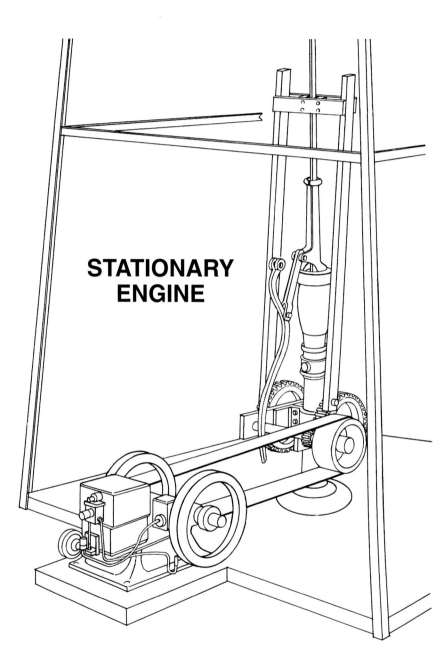

STATIONARY ENGINE

Harness & Trappings

My local farmer friend and I decided it might be a good idea to illustrate a harness with trappings since a lot of people today are not familiar with horses at work in the farm fields. The Amish, of course, still use draft horses for fieldwork, as well as the lighter coach-type horses for their buggies. Then there are those folks who raise draft horses as a hobby, and some even do fieldwork with them. To witness the raw power of draft horses at work is truly a marvelous sight.

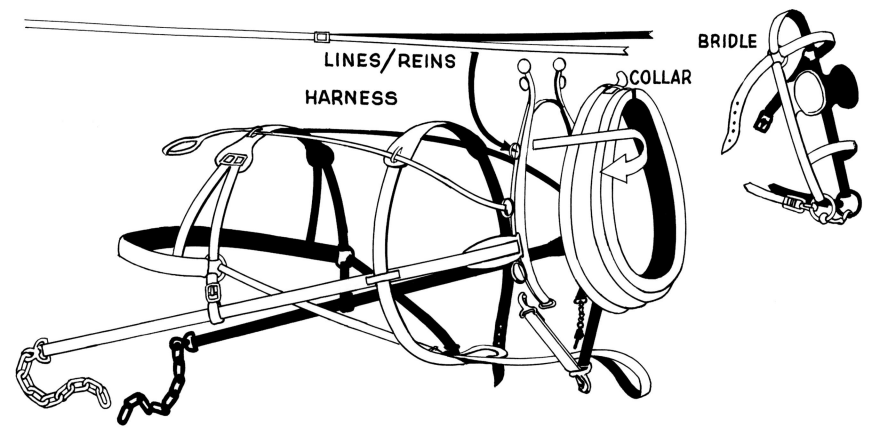

LINES/REINS

HARNESS

COLLAR

BRIDLE

Horse Hitches

Illustrated here are two common hitches with labels to identify the various parts. There are, of course, more hitches, such as the three-horse-abreast hitch, the tandem hitch—which places three horses in back and two in front or vice versa—and a few others. In the tandem hitch, a chain or rod connects the hitch for the front horses to the implement being pulled.

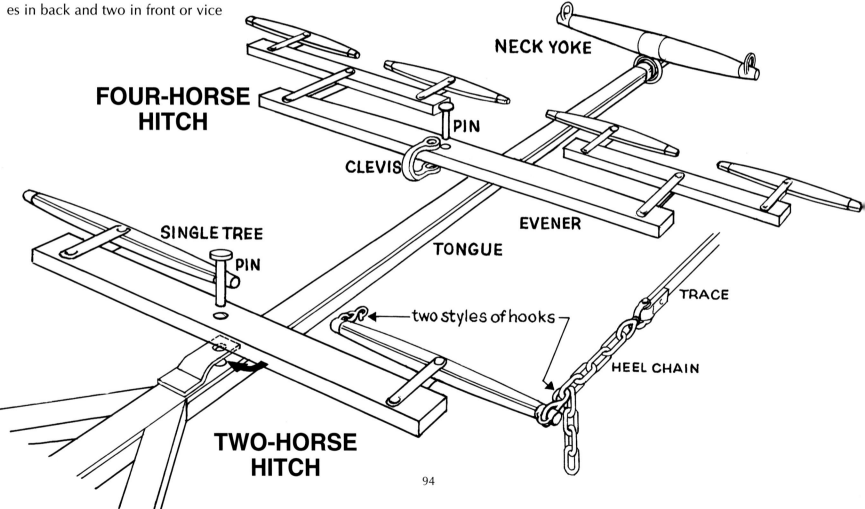

FOUR-HORSE HITCH

NECK YOKE

PIN

CLEVIS

EVENER

TONGUE

SINGLE TREE

PIN

two styles of hooks

TRACE

HEEL CHAIN

TWO-HORSE HITCH

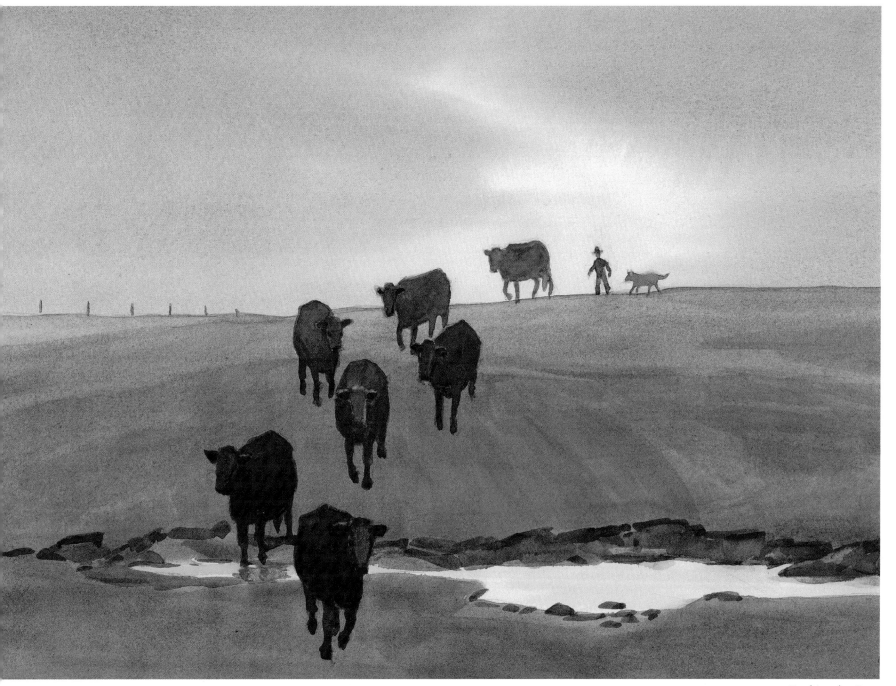

Fetching the Cows

A TRIBUTE TO FARM WOMEN

Talk about women doing a man's work! It was common in those days for a farm wife to help in just about every job that had to be done on the farm, except for the heaviest jobs.

If it turned out that a farm family was made up of all girls, the girls were put to work just as if they were boys. The wives helped out with chores in the field, as did the girls. However, girls weren't expected to start with these duties at as early an age as boys.

Women were heavily involved at butchering time. This was a major undertaking on the farm and required teamwork that almost resembled an assembly line. Butchering chickens fell to the women.

Many parts of the animal were put to use so that there was very little waste. In the case of pork, the small intestines were thoroughly cleaned and used as casing for making sausage. Headcheese was another by-product of the hog. The ingredients were pork rind and head meat, both ground up and then pickled. Liverwurst, a typical German sausage, also contained meat from the pig's head along with the liver.

Cracklings were a special treat. They were obtained by rendering hog fat, and after draining, the meat particles remaining were cracklings. While the lard was being rendered, spare ribs were cooked during the "meltdown".

There was much canning of meat in those days, whether it was beef, pork or chicken. In addition to meat, fruit and vegetables were canned. Almost every fruit and vegetable found on the farm made its way into mason jars. Cucumbers became pickles, and there was pickling of other vegetables and fruit as well.

And then there was Grandma's lye soap! I can well remember Grandmother Riesen making lye soap in a big cauldron she had in the basement with a hot fire in the firebox under it. After butchering was over, the tallow that remained was placed in the cauldron, along with salt and lye. The mixture was stirred with a wooden paddle until it became fluid. It was then placed in assorted utensils and allowed to cool.

When cold and hardened, the resulting soap was cut into blocks and stored uncovered. At the time of use, the blocks were shaved into coarse flakes, which made the soap lather more readily. It made for an excellent laundry soap, its primary use.

On top of all that, there was the washing, ironing and mending. In fact, men's overalls often ended up being more patches than the original denim!

Of course, we can't forget the children that they bore and cared for! There was no such thing as day care. What a monumental task those farm wives undertook, rather akin to what the pioneer women had to endure.

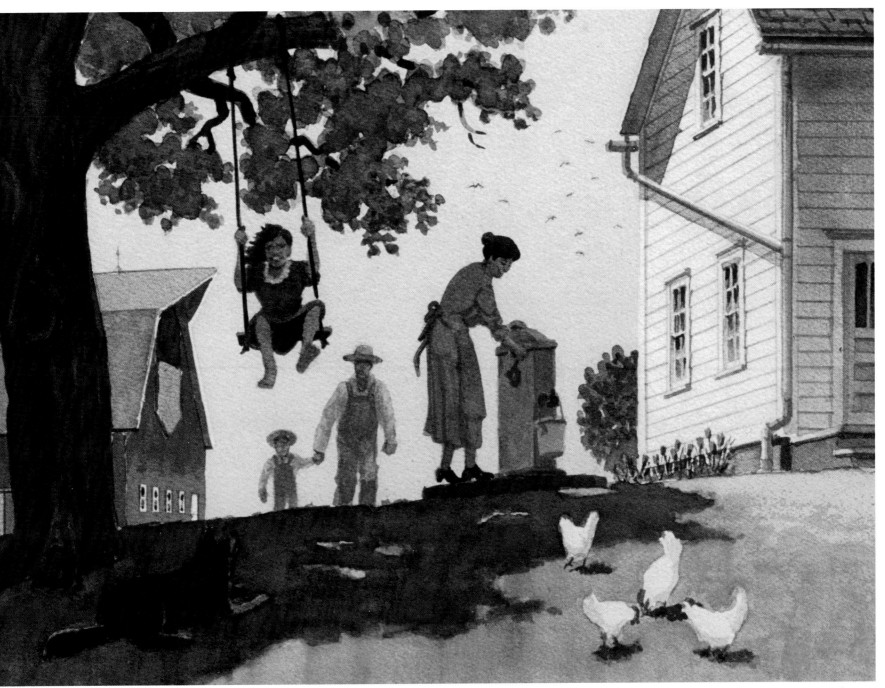

Family Time

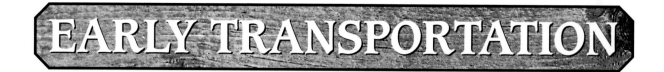

EARLY TRANSPORTATION

There were plans for several homebuilt planes available for aircraft enthusiasts in the '20's and '30's. One was the Heath Parasol; another was the Pietenpol, designed by a Minnesotan of the same name. There are Pietenpols still flying today.

The power for the Pietenpol was provided by a converted Ford Model A auto engine. A shirttail relative of mine who built a Pietenpol tried using a four-cylinder Indian motorcycle engine, but it simply wasn't powerful enough to get the airplane off the ground. He had to use the Ford engine called for in the plans.

The so-called first flight of the Pietenpol was held on a beautiful Sunday afternoon in a cow pasture about 10 miles northwest of Hillsboro. There was a lot of publicity for the event, and a program was part of it. Even a stage was set up. After all, this was a first in the area.

When it came time for the flight, the crowd lined the marked runway to see the takeoff. A hush fell over the crowd as the plane gathered speed, then a loud ovation erupted when it lifted into the air. I found out later that it wasn't actually the first flight. Very early one morning, the test pilot had flown the Pietenpol to be sure there wouldn't be any problems in front of the crowd.

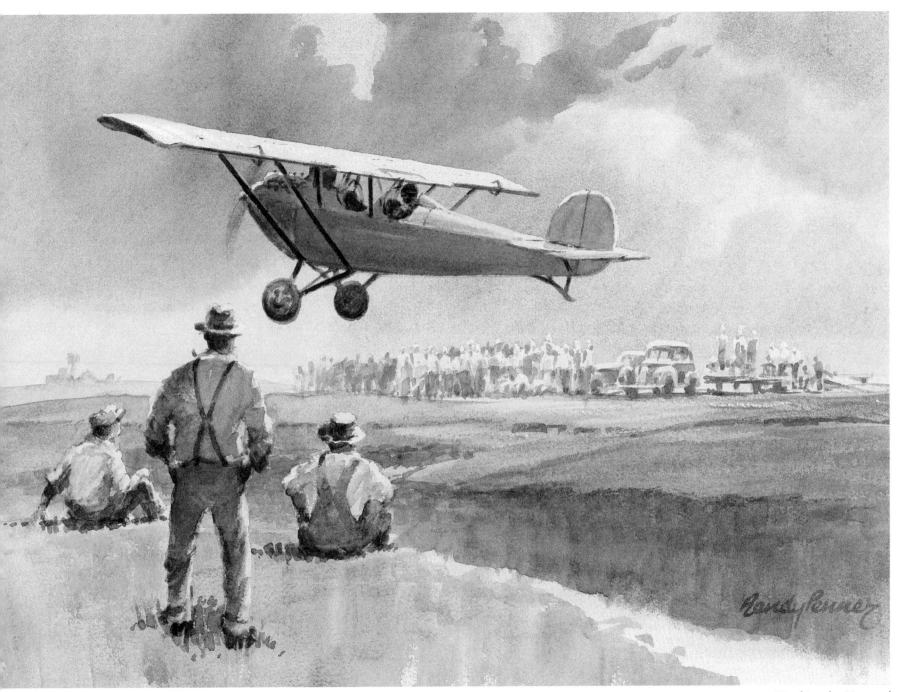

Watching the Pietenpol

MY FASCINATION WITH PLANES

I have many vivid childhood memories of seeing airplanes since we lived only 60 miles north of Wichita, then known as the "Air Capital of the World". It was the home of Swallow, Travelair, Stearman, Cessna and Beechcraft, familiar names to anyone interested in aviation. Cessna and Beechcraft, though under different ownership, have survived to this day.

I'll never forget the big old biplanes that dominated the skies in those days. Monoplanes were on the scene as well. The Ford Trimotor was the first transport plane to really make a mark as a reliable form of transportation.

We had a dentist in Hillsboro, one Dr. G.S. Klassen, who owned a Curtiss Robin, a cabin monoplane, which he kept in a pasture on the southeast edge of town. As I recall, he had a T hangar for it. He loved to give rides, but one of his favorite things was to dump rolls of toilet paper out over town, creating long white ribbons floating down ever so gently.

At Christmastime, a parachutist from Wichita dressed as Santa Claus bailed out over town from Doc Klassen's plane. He descended in his parachute and came down on the edge of town.

I remember well the single-engine Fokker I saw flying low over a county road late one sunny afternoon. There was a record-setting transcontinental flight in a Fokker of the type I saw at about the same time, and I have to think that was the airplane. I can see it now as though it happened yesterday.

My first airplane ride was in a Piper Cub out of a little airport at Newton, a town between Hillsboro and Wichita. The family had driven to nearby North Newton for a church music festival on a summer Sunday. A buddy and I walked to town, so we stopped at the little grass-strip airport and I paid my dollar to go up. This would have been in the late '30's.

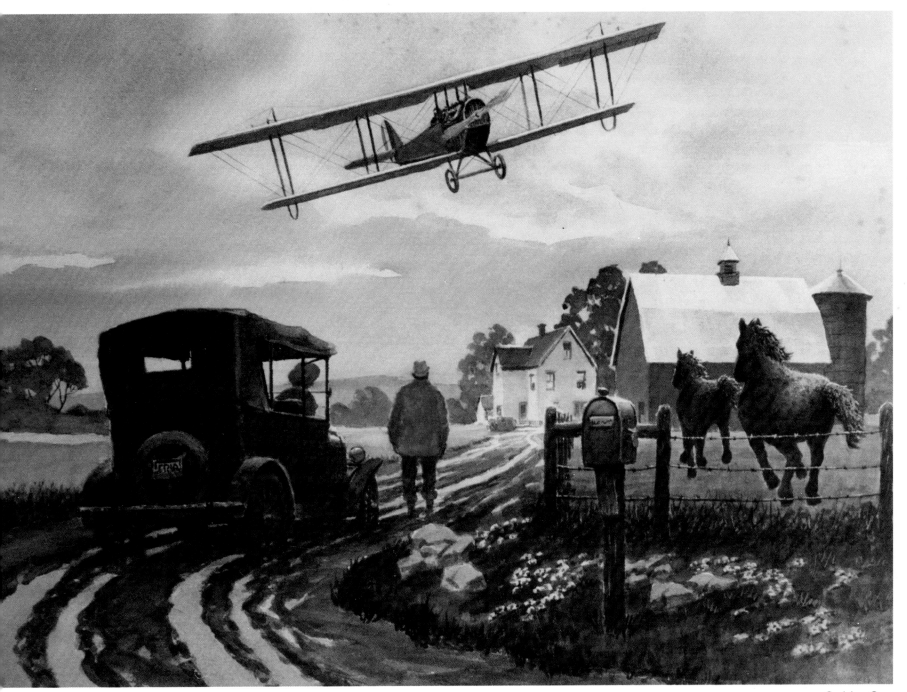

Cruising Over

Fordson and Interurban

RAILWAYS OF MY YOUTH

An interurban ran through a number of towns in our area, including Hillsboro. Known as "The Doodlebug", it was a single unit that contained the power unit, a section for freight and the passenger section. It shared the railroad track with trains and was quite popular for transporting freight and for commuting the relatively short distances involved. Trucks were not too common as yet, certainly not semis or the 18-wheelers and double bottoms seen on today's roads.

I shall never forget the romance of the steam locomotive era. There was something awe-inspiring about those giants of the rails, and the sound of the monsters was something else. We lived 20 miles from Newton, which was on the main line of the great Santa Fe Railroad. The passenger trains were pulled by faster locomotives, and the express trains made fewer stops en route to the West Coast. To see them speed across the prairies was a memorable sight.

In the latter days of steam-powered locomotives, some of the major rail lines were putting streamlined jackets over their es-

pecially fast units. They were then given some exotic name. Santa Fe's locomotive was called the Blue Goose.

I was a passenger on a steamer train only once back then. My sister, Aunt Anna Gertrude and I were returning from Oklahoma after Dad's second marriage in Geary. We rode the Rock Island Line, just like in the song. I was so enthralled by the steam engine that every time the train headed into a curve in the tracks, I would stick my head out the window to see the locomotive!

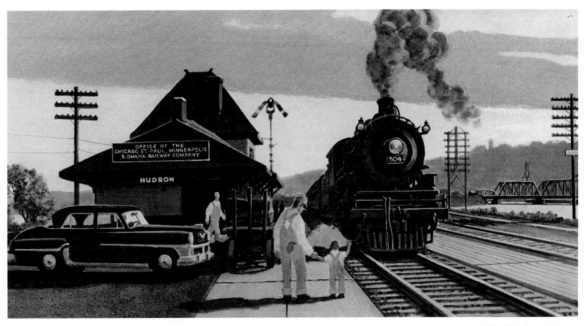

The Hudson Depot

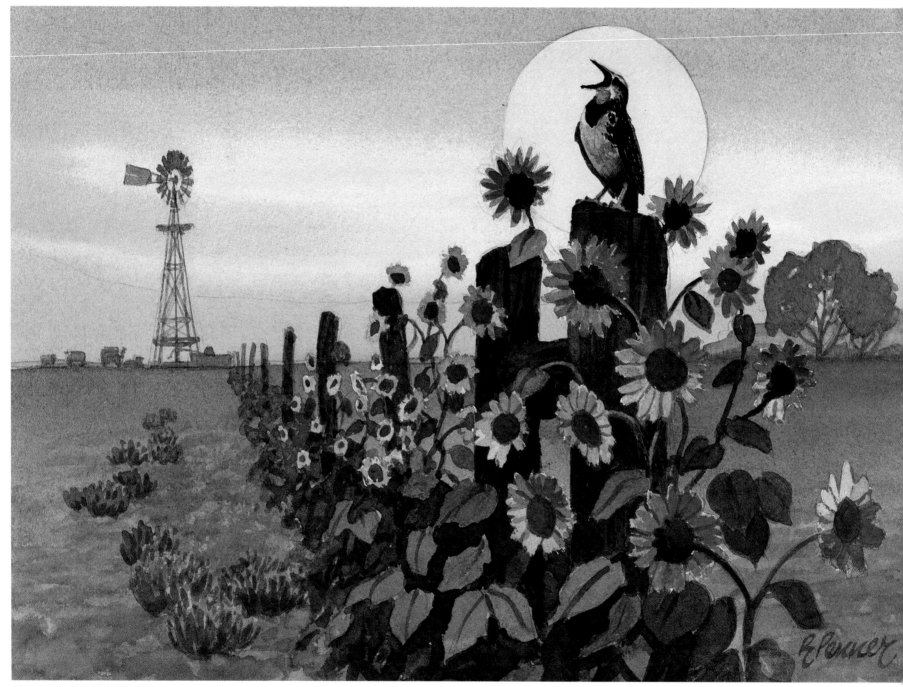

Meadowlark Greets the Day

COUNTRY SENSES

The aromas of newly turned soil and fresh-cut alfalfa, the pungent odor of just-spread manure, the sweet-sour scent of horses sweating, the wonderful freshness after a rain shower, perfume-like clover in bloom and unique aroma of wheat straw during harvest—all of these tickled the olfactory nerves of the farmer.

Then there were the country sounds, some eerie, but most a delight to the ear. The roosters greeted the new day with their crowing, and the western meadowlark would sing gloriously from atop a fence post at first light.

Another early morning greeter was the cock pheasant. The "bob-white" call of the quail was more commonly heard. As the day wore on, many other sounds came forth. I remember the mournful song of the yellow-billed cuckoo, also called a rain crow. Supposedly, the song of the bird signified that rain was in the offing.

Not all sounds were from nature's creatures, however. The creaking of wagon wheels, the sounds of a windmill in motion, the rhythmic clatter of the pump, and the sound of sickles on grain binders and mowers in their rapid back-and-forth cutting motion were just a few of the everyday "man-made" sounds. If tractors were being used, the John Deere, being a two-cylinder, had its own popping sound, which led to its nickname of "Johnny Pop".

Back in the farmyard, there was the chirping of English sparrows, which populated every farm. There was cooing of pigeons, another bird of which most farms had too many, and the constant clucking of the hens. When they came upon some tasty morsel, their clucking took on a higher pitch. That would bring the rest of the flock running. The grunting and squealing of pigs and the bawling of calves were also part of the farmyard symphony.

As the day drew to a close, a new orchestra took over. The cicadas, which sang some during the day, began their group singing in earnest. The lowing of cattle, often cows calling for their calves, could be heard after the sun went down. Often as not, coyotes could be

heard howling, some near and some far, and that would surely bring the cows to bawling for their young ones to join the herd for protection. On quiet moonlit nights, a mockingbird would alight on the very top of the windmill and begin his serenade. His repertoire was limitless and a joy to listen to.

The eerie hooting of the great horned owl was especially haunting to me. That, along with the croaking of bullfrogs in the creek, was special nocturnal music to my ears.

MILKWEED

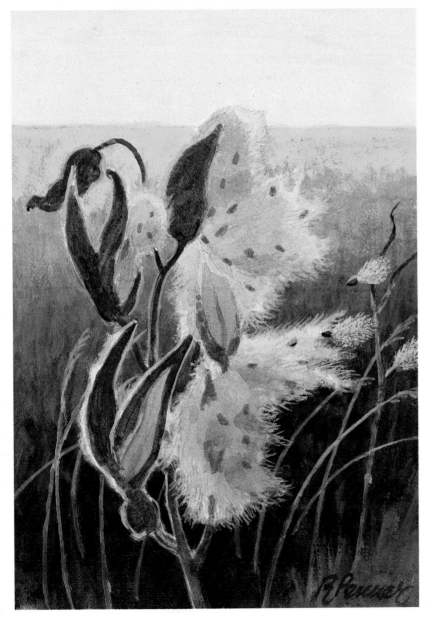

Milkweed was a common weed on the farm, usually found along roadways and fence lines. These plants exude a milky, sticky substance, hence their name.

The lowly milkweed possesses a certain beauty, especially when the sun is low in the western sky during the fall of the year. The seed pods burst and the cotton ball-like contents are silvery against the sun. In any kind of breeze, the seeds, with their individual "parachutes", escape the mother lode and are wafted away ever so softly.

As many old-timers will remember, the cotton-like contents of the milkweed seed pods were collected during World War II for use as flotation in life vests. This stuffing was called kapok.

An interesting aside on milkweed: Of the number of different kinds of milkweed, the species common in Kansas is very poisonous to livestock, which usually avoid it anyway.

COMMON FARM FLOWERS

Lilac Lane

Easily the most common flower of the fields was, and is, the sunflower. After all, Kansas is known as the Sunflower State. The sunflowers thrived even during the drought years. To me, the bright yellow petals represented the hot blazing sun, while the brown centers symbolized the parched earth.

Aside from wildflowers, there were a few flowers that were commonly found on farmsteads. The hollyhock was a standard farmyard flower, often seen around the base of windmills as well as in gardens. The hollyhocks' unusual height provided a colorful screen.

Lilac bushes were also found on most farms, often serving as hedges. The simple beauty of a lilac hedge in bloom was a springtime delight, a harbinger of summer.

Morning glories were fairly common, too. The flower-bedecked vines covered the skeletons of trellises. I always found something soothing about the pale pastel blues dusting the white of the flowers.

Hollyhocks

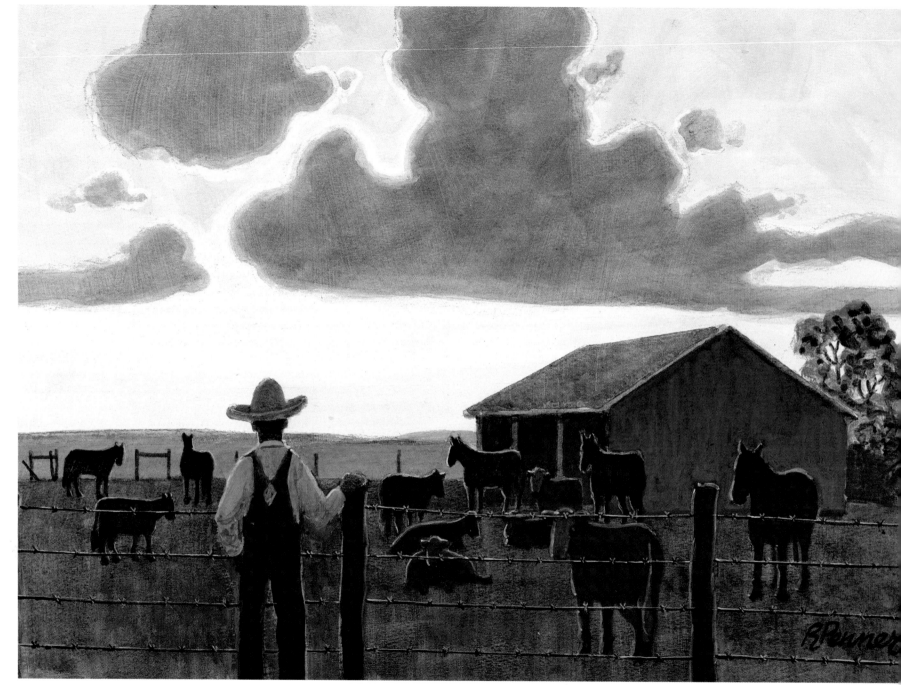

Day's End

EVENTIDE AT THE OLD CORRAL

Barn at Sunset

On a warm summer evening, I would stand at the corral fence and drink in the peace and tranquillity of nature and her creatures at rest. The day's work was done, and labor could wait until the dawn of a new day. Man and beast were at ease.

The glorious sunsets that bless the Plains states like none other are truly one of the wonders of the universe—God's paintbrush at work!

OVER THE RAINBOW

There wasn't a pot of gold at the end of our rainbows, but they signaled the arrival of much-needed moisture.

Over the years, I've learned a few interesting things about rainbows in addition to the fact that they are only seen when the sun shines after a rain shower. If the rain was heavy, the rainbow may appear clear across the sky, forming a complete arc. There are actually seven colors in a rainbow, but the observer usually doesn't see more than four or five because of the subtle blending of one color into another.

Have you ever wondered why you see so few rainbows in paintings? I think it's simply because getting that subtle gradation of seven colors within a very narrow band is extremely difficult.

The higher the sun, the lower the rainbow, and if the sun is quite high, no rainbow is visible. If the sun is very low, a person on a high mountain or in a balloon may possibly see the complete rainbow circle, believe it or not. The sun has to be behind the viewer and the rain in front in order for the rainbow to be seen. A thought…do you suppose birds and animals can see rainbows?

Rainbows are truly one of nature's spectacular events. I'm sure there are myths and "old wives' tales" about rainbows. For sure, they were harbingers of the breaking of the long drought that plagued so much of the nation back when I was a child. What a welcome sight they were, after such a long time of not seeing any!

Rainbow

In Closing...

TO THOSE OF YOU who are old enough to remember the '20's and '30's, I hope this book has brought back memories. To those who weren't around then but wonder what it was really like, I hope this book has provided insight.

I've shared with you my youthful trail
Through the times of joy and travail.

Many memories, good and bad
Came to mind for this old lad.

It's my hope that you've enjoyed
The efforts of this old farm boy.

Bless you all!
Randy Penner

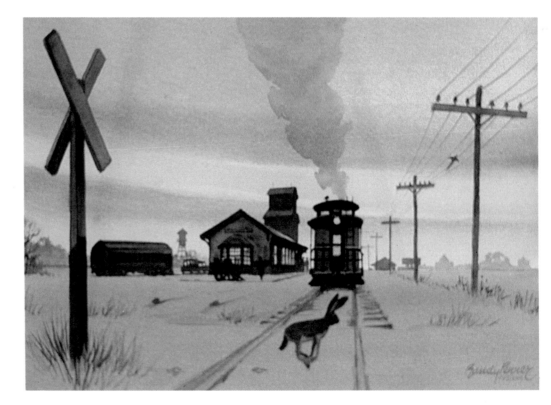